Femme Fatale

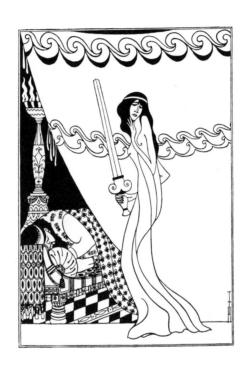

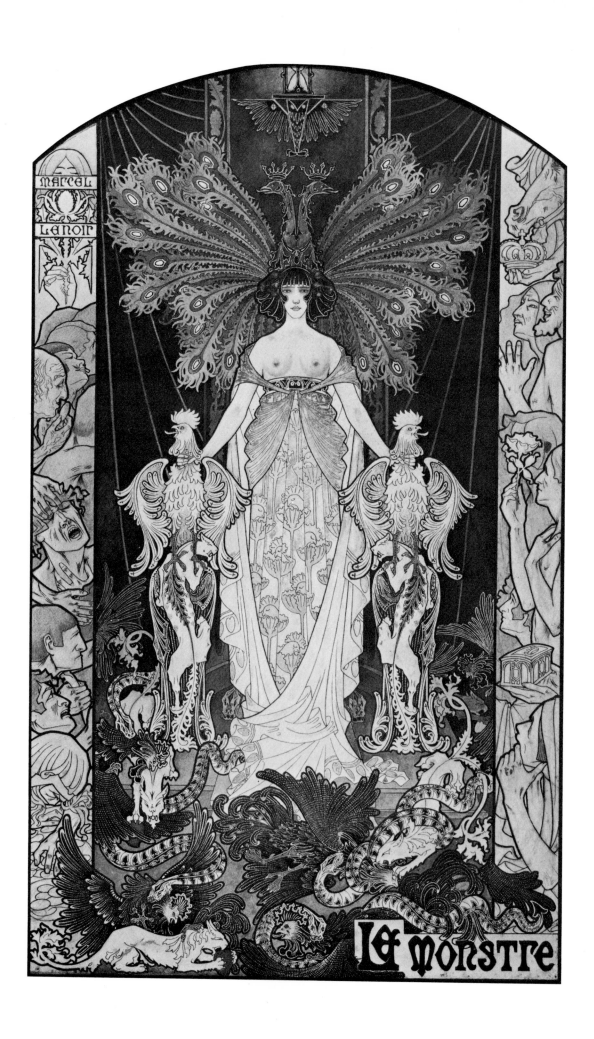

Femme Fatale

Images of evil and fascinating women

Patrick Bade

MAYFLOWER BOOKS

Pages 1 and 4 Thomas Theodor Heine,
Illustrations to Friedrich Hebbel's play
Judith 1908.

Page 2 Marcel Lenoir, *The Monster* 1897.

Page 5 Ford Madox Brown, *The Stages of
Cruelty* 1856-90.

Library of Congress Cataloging in Publication Data
Bade, Patrick.
 The femme fatale.
 1. Femmes fatales in art. 2. Arts, Modern—19th century.
I. Title.
NX650.F46B32 700'.9'034 78-11577
ISBN 0-8317-3250-4
ISBN 0-8317-3251-2 Pbk

Manufactured in Great Britain

First American edition

You are crueller, you that we love,
Than hatred, hunger, or death;
You have eyes and breasts like a dove,
And you kill men's hearts with a breath.

Algernon Charles Swinburne *Satia Te Sanguine*

Femme Fatale

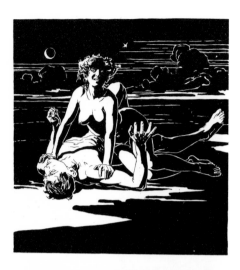

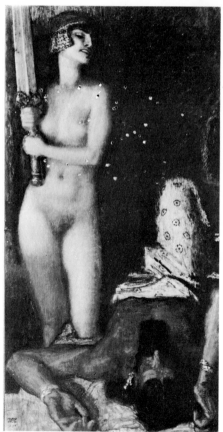

Top Ernst Stohr, Illustration from the magazine *Ver Sacrum* 1900.

Above Franz von Stuck, *Judith*. The biblical heroine Judith was transformed in the late nineteenth century from an example of piety and courage into a voracious femme fatale.

She is older than the rocks among which she sits; like the vampire, she has been dead many times, and learned the secrets of the grave; and has been a diver in deep seas, and keeps their fallen day about her... Certainly Lady Lisa might stand as the embodiment of the old fancy, the symbol of the modern idea.

Walter Pater *La Gioconda*

In the second half of the nineteenth century there was an extraordinary proliferation of femmes fatales in European art and literature. Wherever he went, the exhibition visitor of the 1890s found walls crowded with malefactors of the female sex. They also appeared with alarming frequency in poetry, plays, novels and operas. By the end of the century they were even to be found on necklaces, advertisement hoardings, perched on ash-trays and inkwells and gazing up from the bottom of soup bowls. This preoccupation with evil and destructive women is one of the most striking features of late nineteenth-century culture. The theme was all-pervasive, appealing to men of opposing artistic creeds, symbolists and realists, rebels and reactionaries, and penetrating deeply into the popular consciousness.

A deep-rooted misogyny had been common among many artists since the beginning of the century. Some painters, among them Delacroix, Corot, Courbet, Degas, Moreau and Munch, avoided marriage, fearing that their work would suffer from female interference. The belief was widespread that women sapped creativity and that they were incapable of elevated feelings or of understanding art. Even George Bernard Shaw, who was ahead of his time in recognising women as intelligent and rational beings, thought that woman and the artist were mutually inimical. In *Man and Superman* John Tanner, who is a mouthpiece for Shaw's views, proclaims, 'of all human struggles there is none so treacherous and remorseless as the struggle between the artist man and the mother woman. Which shall use up the other? That is the issue between them.' Gustave Moreau spoke for many when he asserted that 'the serious intrusion of women into Art would be an irremediable disaster'. Hostility towards women was often accompanied by an ambivalent attitude towards sex. The association of eroticism with pain and death and the belief that sexual relations entail a subjugation, often violent and destructive, of one partner to the other, run through much of nineteenth-century art. But in the course of the century, artists interpreted this subjugation in a new form, shifting from a sadistic to a masochistic conception of sex roles in which the woman was dominant.

This conception was a male one. In nineteenth-century art women are seen almost exclusively through the eyes of men. Although there were increasing numbers of women artists and art education was gradually opening up to them, most of the art of the period was still produced by men. In the work of the few notable women artists such as Berthe Morisot, Mary Cassatt and later Suzanne Valadon and Gwen John, the femme fatale is conspicuously absent. These women artists tended to concentrate on the domestic side of female character and experience. This is in marked contrast not only to their male contemporaries, but also to women artists of the Baroque period. Artemesia Gentileschi, and others, liked to paint women of action such as Salome and Judith. The popularity of these subjects in the seventeenth century demonstrates the very different connotations which such subjects had in earlier periods. Judith, for example, had been the model of the patriotic and heroic woman rather than a femme fatale. The early Baroque period offers close parallels to the nineteenth century in the treatment of violence. The work of Caravaggio and his followers shows a fascination for the horrific and gruesome, and sado-erotic elements are

much in evidence; but, there is still no particular emphasis on the woman as destroyer.

Nineteenth-century artists drew their femmes fatales from a wide variety of historical and literary sources, as well as reworking and transforming many traditional themes. The Bible offered an impressive array of potential subjects: Eve, Jezebel, Delilah, Judith and Salome. To these should be added Lilith, who according to Jewish folklore was the first wife of Adam and was later transformed into a demon. Three stories held a special fascination because of the fate of the victims: that of Judith, the Jewish widow who decapitated the Philistine general Holofernes after making love to him; of Salome, who demanded the head of John the Baptist as reward for dancing before Herod; and of Delilah, who destroyed Samson's strength by cutting his hair and then betrayed him to his enemies who put out his eyes. Decapitation or the gouging out of eyes can be seen in the works of many late nineteenth- and early twentieth-century artists as a metaphor for castration. Salome exercised the most powerful attraction of all. In earlier centuries Salome appeared relatively infrequently in European art, but in the second half of the nineteenth century she was elevated to the status of an archetype. Elaborate fantasies were woven around the terse and equivocal narrative of the gospels by the writers Heinrich Heine, Gustave Flaubert, Stéphane Mallarmé, Jules Laforgue and Oscar Wilde, and the composers Jules Massenet, Richard Strauss and Florent Schmidt, not to mention the innumerable painters and illustrators who were in their turn inspired by the writers.

The ancient world too was fertile ground. From Greek mythology came Helen of Troy, Circe, Medusa, Medea, and the Sirens, and from Babylonian mythology Astarte, who was the bringer of death and decay as well as of fertility, and who in the manner of certain insects destroyed her lovers. There were also historical figures famed for excesses of sensuality and for their powers of seduction, such as Messalina and Cleopatra. Pre-Roman Carthage and post-Roman Byzantium offered an ideal setting for the femme fatale. The oppressively luxurious and decadent atmosphere of these societies, threatened with disintegration from within and destruction from without, answered the mood of fin-de-siècle Europe. Carthage, in fact, had no legendary or historical fatal woman, so Flaubert was forced to invent Salammbô, the heroine of his great historical novel.

The Middle Ages appealed strongly to the English Pre-Raphaelites and their followers and so potent was their imaginative recreation of the period that we still tend to view the medieval world and in particular its heroines through Pre-Raphaelite eyes. Iseult, Guinevere and Francesca, through their beauty and their illicit passions, were, like Helen of Troy, the unwilling cause of discord and death. Venus in her medieval guise as the villainess of the Tannhäuser legend, La Belle Dame Sans Merci and the two evil women of the Arthurian legends, the witch Morgan-Le-Fay and the enchantress Nimue, were femmes fatales of a more malignant kind.

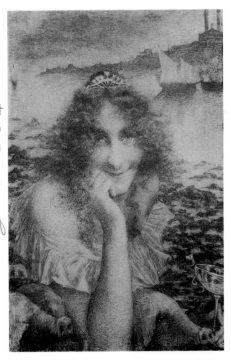

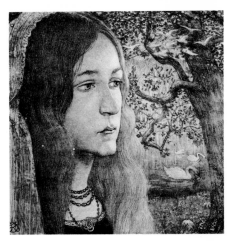

Top Lucien Lévy-Dhurmer, *Circe* 1895. Despite the Leonardesque smile and the galleys of Odysseus whose men she has changed into pigs, this enchantress, with her champagne glass, has the look of the 1890s.

Above Richard Holst, *Helga* 1894. The diabolical beauty of this heroine of ancient Irish myth drove men to fatal combat.

Left Henri Martin, *Towards the Abyss* 1897. This kind of apocalyptic vision became fashionable as the turn of the century drew near. Characteristically, it is a woman who leads mankind towards its doom.

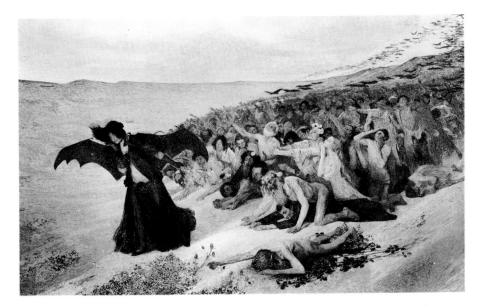

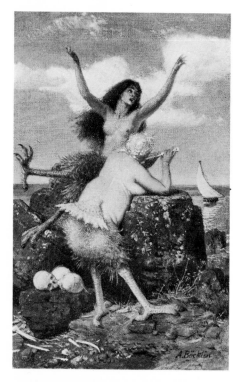

The commonly held notion of the Renaissance as an age of lawless and amoral cruelty was also a product of the nineteenth-century taste for vicarious wickedness. This view was propagated by the writings of the historians Jacob Burckhardt and Jules Michelet and of two Englishmen associated with the Pre-Raphaelite movement, the aesthete Walter Pater and the poet Algernon Swinburne. Pater's famous eulogy to the Mona Lisa, 'the diver in deep seas', became a classic description of the femme fatale, while Swinburne popularized Lucrezia Borgia and Mary Queen of Scots among his Pre-Raphaelite friends.

Hybrid monsters – half animal, half woman – formed a special category of femme fatale. The Sphinx took on a new lease of life and artists were extraordinarily inventive in adding new creatures to the repertory, joining the heads and breasts of women on to the bodies of insects, reptiles, snakes, various members of the cat family, vultures, and in the case of one horrific painting by Böcklin, even chickens. These creatures were representations of the base or animal side of woman, rather as the centaur and the satyr were of man in classical art. Most of the animals used in these transplants were chosen for their repulsive and predatory characteristics – qualities which were also attributed to women.

In many paintings and descriptions of the femme fatale there is a hint of bestiality. The fatal woman is often attended by animals, and a kinship or secret understanding between them is implied. Legendary examples of bestiality were often depicted and it was by reason of their monstrous matings that Leda and Pasiphae were included among the femmes fatales. The heroine of *Alpha and Omega*, a short story by the Norwegian painter Edvard Munch, mates with all the animals of the forest and causes them to tear each other apart in jealous rage.

Sirens, mermaids, nymphs and other female inhabitants of the watery regions represent another numerous and important group. The symbolic association of women and water has a long-standing tradition in European art, but in the nineteenth century it was given a particularly sinister twist. Death by drowning was a common fate for male victims of the femme fatale, and is a recurrent image in late nineteenth-century art. Again, this fate can be interpreted as an unconscious metaphor for man's fear of being overwhelmed by female sexuality, or for loss of identity and self control in sexual intercourse.

The choice of subjects from distant places or historical periods enabled artists and writers to cast about their heroines an aura of mysterious remoteness and also provided an excuse for exotic and picturesque trappings. But no matter where the artists and authors found their subjects, these women all bear the unmistakable stamp of the artist's own period and a marked family resemblance to one another. They are pale, proud, mysterious, idol-like, full of perverse desires yet cold at heart. The link between eroticism and death is always present, as is an atmosphere of perverse cruelty which became increasingly intense as

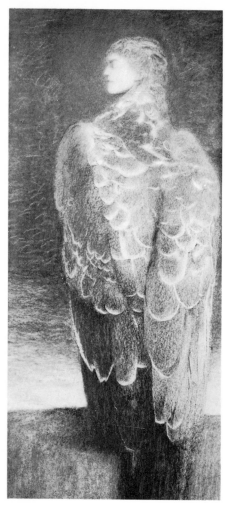

Top Arnold Böcklin, *The Sirens* 1873.

Above Fernand Khnopff, *Medusa Asleep* 1896.

Right John William Waterhouse, *Ulysses and the Sirens* (detail) 1891.

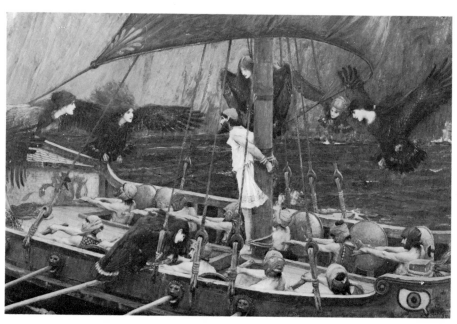

the century drew to a close. For many artists, it hardly mattered whether they painted Helen of Troy, Judith or Morgan-Le-Fay. The subject was always perceived in the same terms: women as malignant, threatening, destructive and fascinating.

Of course wicked women had always existed in art as in life, and there had always been men who feared female sexuality or who took a masochistic delight in fantasies of fatal women. The superstitions that women are bringers of ill-luck and that they sap men of their virility and creativity, that they are tainted with evil and devious and mischief-making by nature are, in more or less primitive forms, universal. According to Christian and Greek myth, both Eve and Pandora brought evil and death to mankind. It would be possible in fact to compile a substantial volume of anti-female pronouncements, drawing upon every culture and period in history. Psychologists have proposed diverse theories in an attempt to explain man's fear of woman. The association in men's minds of women with death and impurity may have some origin in a primitive anxiety about menstruation; but castration fears and suspicion of feminine 'deviousness' are perhaps the price that men have paid for their continuing domination of the female sex.

It should also be remembered that in the nineteenth century, when there was still no effective cure for syphilis, women often were quite literally the carriers of hideous disease and death. Prostitution was by far the 'profession' most widely practised by women; there are no reliable figures but it has been conservatively estimated that in the mid-century one in sixteen of the entire female population of London was engaged in prostitution. This certainly has some bearing on the frequent association of love and death, of beauty and disease in nineteenth-century art. The cult of the 'Vie Bohème' and the belief that artists should not be bound by the rules of bourgeois morality, meant that artists and writers were particularly susceptible to the dangers of infection. Among the many artists and writers who died of the effects of syphilis were Baudelaire, Maupassant, Manet and Gauguin. There is particular irony in the fact that Baudelaire and Maupassant should have died in this way, since both had delighted in the feline qualities of women and in their destructive potential. It does not seem to have occurred to the male artists and writers of this time that men rather than women might be blamed for the spread of syphilis. An etching entitled *Mors Syphilitica* by the Belgian artist Félicien Rops, is one of many representations of death in female form. The Dutch writer, Joris-Karl Huysmans, in his notorious novel *Against Nature*, which was regarded as a manifesto of decadent taste, indicated the connection between the femme fatale and venereal disease when he described Gustave Moreau's *Salome* as having 'the charms of a great venereal flower, grown in a bed of sacrilege, reared in a hot-house of impiety'. The theme of hereditary syphilis, passed on by the mother to the child, is dealt with by Henrik Ibsen in *Ghosts* and by Munch in his painting *Heredity*. In both of these works the mother's biological role is perverted; she passes on to her children not only life but also the seeds of disease and death.

The nineteenth century was notably well-endowed with real femmes fatales. From the middle of the century until the First World War such notorious courtesans as Cora Pearl, La Païva, Lillie Langtry and Otéro were conspicuous in society. It became fashionable to be ruined by one of these women. Indeed their reputations were based on the numbers of lovers they had ruined and the vast fortunes they had devoured. Extravagance was their best means of self-advertisement. The first requisite of the successful courtesan was a lack of natural feeling. Cora Pearl confessed that she had 'an instinctive horror of men' and it was said that she was kinder to her horses than to her lovers. The ugly and charmless La Païva reached the top by steely determination. The poet Émile Bergerat shuddered superstitiously when he saw her at a concert followed by the handsome and wealthy German prince who was her lover:

> You either believe in vampires or you don't, I believed in them at that concert. If the terrible lemur who so patently held this Siegfried in bondage was not a known corpse, that is because there are some who return by the light of the moon to drink the blood of white cuirassiers. She had their Purple on her lips, and the rest was livid, glazed, and in dissolution.

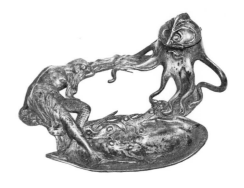

Top Art Nouveau inkwell.

Above Félicien Rops, *Kisses of Death*.

Below The courtesan Cora Pearl.

Alberto Martini, *Berenice* 1908. This figure displays the gleaming white teeth which obsess the hero of Poe's sinister short story, *Berenice*.

Opposite page:

Above left Auguste Rodin, *The Eternal Idol* 1889.
Above right Théodore Rivière, *Salammbô and Mâtho* 1898.
Both Rodin and Rivière express man's subjugation to woman, Rivière in a more literal and literary fashion by illustrating a scene from Flaubert's novel.

Below left Max Klinger, *The Modern Salome* 1893.
Below right Jean-Léon Gérôme, *Corinth*. Polychrome sculpture lent itself to effects of sinister decadence. Klinger's bust was an attempt to make a general statement about the nature of women. Gérôme's figure of a sacred prostitute sat idol-like atop a tall column.

The reign of the 'Grandes Horizontales' (so named after the position in which they were reputed to earn their money) corresponded exactly in time with that of the femme fatale in art and literature.

The astonishing change in society's attitude towards high class prostitutes was paralleled by a drastic reversal in the attitudes of male artists towards women. In the art and literature of the first part of the century most often it is the man who is fatal and the woman who is the victim. In *The Romantic Agony* Mario Praz describes the fatal man as the earlier counterpart of the fatal woman. He bears many of the same features which were later to characterize the femme fatale. He is pale, impassive, mysterious, with a mirthless smile and a dangerous magnetism. In literature it was Byron who set the pattern and in painting it was Delacroix. The Byronic hero, existing under a curse, driven by dark and destructive passions, was, in the words of the Earl of Lovelace, 'destined to wreck his own life and that of everyone near him'. Like the femme fatale he inevitably destroys those he loves. Byron's Manfred laments, 'My embrace was fatal . . . I loved her and destroyed her.' Delacroix's painting, *The Death of Sardanapalus*, inspired by a verse play by Byron, depicts women as the helpless victims of the destructive male. Delacroix squeezes every last drop of sado-erotic sensation from the conclusion to Byron's drama in which an eastern potentate has his wives and mistresses killed at the moment of his own death. The lovely naked bodies of the women are thrust into the most voluptuous and provocative poses as they have their throats slit at the whim of their master.

The characteristic woman of the early period of Romanticism is fragile, loving, vulnerable, sometimes ailing, like Marguerite Gautier, 'The Lady of the Camellias'. She may be tainted or 'fallen', often the result of seduction and betrayal. If she is fatal, it is to herself alone. Favourite literary heroines of the painters were the Marguerite of Goethe's *Faust* and Shakespeare's Ophelia, both driven by love to insanity and death. Artists and poets were clearly moved and erotically stirred by the sufferings of women. The death of a beautiful woman was described by Edgar Allan Poe as the most poetic subject in the world. From English painters in the 1840s came a stream of paintings which gloated over the misfortunes of governesses, seamstresses and other virtuous and impoverished young ladies.

The femme fatale was discovered by poets some years before she was taken up by painters. Keats, who in so many ways anticipated later trends in nineteenth-century art, was attracted to the theme as early as 1819 when he wrote *La Belle Dame Sans Merci*, inspired by the Tannhäuser legend which later served Wagner, Swinburne, Burne-Jones and Beardsley. In France, Théophile Gautier took up the fatal woman in such stories as *A Night with Cleopatra* (1845), surrounding her with a heady, exotic atmosphere. This vein of exoticism was mined more thoroughly by Gustave Flaubert. In his novel *Salammbô* he presented one of the most compelling and influential portrayals of a femme fatale. The priestess Salammbô is distant, idol-like, frigid and scarcely human. The slave Mâtho, who dares to love her, dies a particularly hideous death.

Even more influential than Flaubert was his exact contemporary, Charles Baudelaire. Baudelaire's feminine ideal was similarly remote, cruel and coldly sensuous. His poetry expresses an ambivalent attitude towards women, compounded of reverence, desire, disgust, fear and contempt, a divided disposition which was to be so characteristic of the second half of the nineteenth century. It was necessary for Baudelaire to view the object of his desire as evil and monstrous. On a drawing which he made of his mistress Jeanne Duval, 'the black Venus' of his poetry, he wrote the motto *Quaerens quem devoret* (seeking whom she may devour). At the same time he needed to place his loved one on a pedestal, to treat her as an idol, untouchable and unattainable. To approach too closely the object of desire was to risk destroying the desire. For five years Baudelaire loved and desired Apollonie Sabatier, his 'white Venus'. But when she finally gave herself to him, he fled, writing to her,

You see my dear, my beauty, that I have hateful prejudices about women. In fact, I have no faith; you have a fine soul, but, when all is said, it is the soul of a woman . . . a few days ago you were a deity, which is so convenient, so noble, so inviolable. And now there you are, a woman.

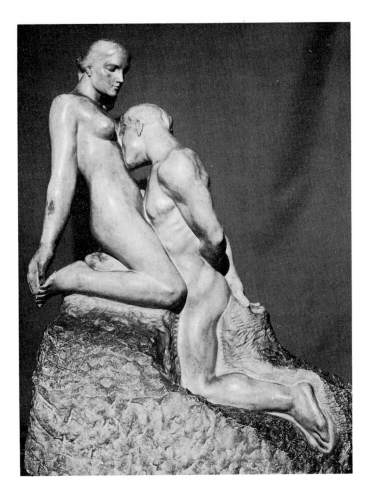

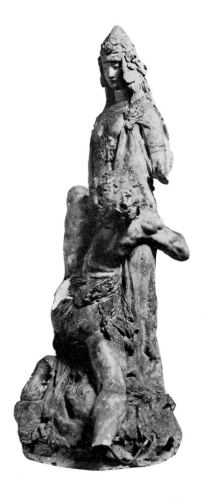

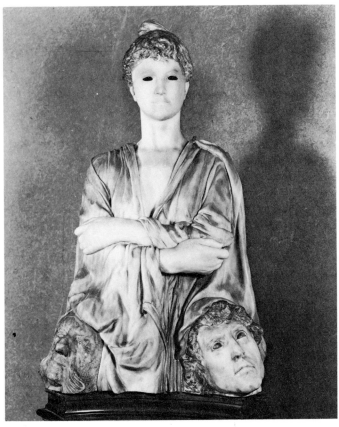

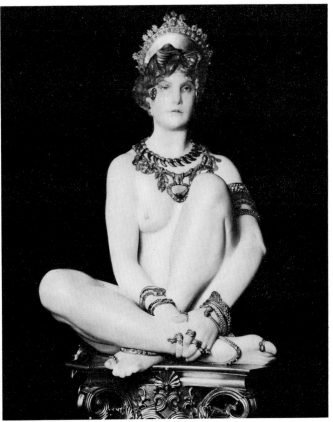

Baudelaire's behaviour demonstrates how reverence can turn to fear, and fear to hatred and vilification – or masochism. In the writings of Baudelaire's English admirer, Algernon Swinburne, it becomes even more apparent that it is but a short step from the pedestal to the flogging block. Indeed *The Flogging Block* is the title of an epic poem in which Swinburne celebrates the pleasures of flagellation. Swinburne's recurrent descriptions of cruel and imperious women and of young men who long for pain and death at their hands are manifestations of his specialised sexual tastes. The sado-masochistic relationship between men and women in his writings was not a literary pose but a reflection of his own nature and it is a curious fact that it found an answering echo in the work of so many other nineteenth-century writers and artists.

Swinburne's ideal of female beauty is admirably conveyed in his description of a drawing of a woman's head by Michelangelo, which bears as little relation to Michelangelo as does Pater's description of the Mona Lisa to Leonardo. In the writing of both men a perversity of taste has transformed the subject almost beyond recognition. Swinburne describes Michelangelo's figure as

> beautiful always beyond desire and cruel beyond words: fairer than heaven and more terrible than hell: pale with pride and weary with wrong-doing; a silent anger against God and man burns white and repressed, through her clear features . . . Her eyes are full of proud and passionless lust after gold and blood: her hair close and curled seems ready to shudder asunder and divide into snakes. Her throat, full and fresh, round and hard to the eye as her bosom and arms, is erect and stately, the head set firm on it without any drop or lift of the chin: her mouth crueller than a tiger's, colder than a snake's, and beautiful beyond a woman's. She is the deadlier Venus incarnate.

Swinburne's portrayal of Mary Queen of Scots as a femme fatale in a trilogy of plays was also a remarkable transformation, especially perverse as Mary Stuart had been a favourite tragic heroine of the Romantics – notably of Schiller, in his play *Mary Stuart*, and Donizetti, in an opera based on Schiller's play. In the first of the three plays Swinburne describes Mary Stuart with a suggestion of vampirism which became an almost inevitable attribute of the fatal and predatory woman:

Aubrey Beardsley, Frontispiece to *Earl Lavender* 1895. Attitudes of trembling adulation could easily change into masochistic self-abasement.

> For all Christ's work this Venus is not quelled,
> But reddens at the mouth with the blood of men,
> Sucking between small teeth the sap o' the veins,
> Dabbling with death her little tender lips –
> A bitter beauty, poisonous-pearlèd mouth . . .

Vampires too had undergone a surprising transformation – a change of sex. In Byron's time vampires had usually been of the male sex but from the middle of the century onwards they were almost invariably female, draining the life force from their chosen mate.

In the 1860s, when Swinburne was at the height of his powers, he was on terms of close friendship with the Pre-Raphaelite poet and painter Dante Gabriel Rossetti and the group of younger artists, including Edward Burne-Jones, who had come under the spell of Rossetti's magnetic personality. By this time Rossetti had led Pre-Raphaelitism far away from the earnest and meticulous 'Truth to Nature' which had been its guiding ideal when it was founded by William Holman Hunt, John Everett Millais and Rossetti in 1848. The kind of Pre-Raphaelitism practised by Rossetti and his followers found its subject matter in literature, history and poetic fantasy. It anticipated and eventually merged into the Symbolist movement which swept through Europe later in the century.

Rossetti's greatest passion in life was for 'stunners'. But the beautiful women who appear with such obsessive frequency in his work are narcissistic projections of his inner self. In an early autobiographical story entitled *Hand and Soul*, Rossetti describes how the soul of the artist appeared to him in the form of a beautiful woman and urged him to paint her so – an interesting anticipation of Jung's theory that man's unconscious, or *anima*, takes a complementary feminine form.

In some respects Rossetti can be seen as a transitional figure. Themes of love and death are always closely entwined in his work, but not all of his women are fatal. Many belong to the earlier type of Romantic heroine. Rossetti's penchant for femmes fatales was undoubtedly encouraged by his friendship with Swinburne, although there are some examples of this interest dating from the earliest part of his career. Already in the 1840s, before the formation of the Pre-Raphaelite Brotherhood, Rossetti had been attracted to the subject of 'La Belle Dame Sans Merci'. *The Laboratory*, one of his first watercolours, shows an eighteenth-century beauty visiting an alchemist in order to procure poison with which to murder a rival. The theme of sirens occurs several times, culminating in his painting *The Seaspell*.

Soon after he met Swinburne, Rossetti painted Lucrezia Borgia, a lady who was a particular favourite of the poet. Swinburne shocked and thrilled his painter friends by declaring that Lucrezia Borgia was greater than Jesus Christ. She was established as yet another archetype of feminine depravity, despite the fact that the historical Lucrezia Borgia had been the pawn of her father, Pope Alexander VI, after whose death she had led a life of good works and blameless domesticity. In Rossetti's painting, she is seen washing her hands in a basin, after preparing a poison for her husband. In a circular mirror, he can be seen hobbling on crutches, the result of a previous attempt to be rid of him. He is being walked about the room by Pope Alexander, 'to settle the poison well into his system', as Rossetti put it. Other destructive females depicted by Rossetti include Lilith, Helen of Troy, Pandora, Venus Verticordia, Lady Macbeth and Potiphar's Wife. Fatal women also occur in his poetry, notably the chilling *Sister Helen*, in which a girl inflicts an agonizing death on her faithless lover by means of witchcraft.

Rossetti's great contribution to the cult of the femme fatale was the creation of a kind of beauty which characterized her throughout her heyday. The fatal women of Gustav Klimt, Aubrey Beardsley and Edvard Munch are still recognisably descended from Rossetti's prototype. Rossetti's ideal had two incarnations in the great loves of his life, Lizzie Siddal and Jane Morris. They share a heavy-lidded languor, a self-absorbed melancholia. Certain features of the first woman are exaggerated in the second: the columnar neck, the lush growth of hair, the thick, sensuous lips and the strong jaw line. The most distinctive characteristics of Rossetti's women are their androgynous appearance and the abundance of their hair. There is already a certain boyishness in the depiction of women inspired by Lizzie Siddal, and in Rossetti's later work the chin, neck and shoulders of his women have an almost masculine massiveness, while the curves of breasts, waist and hips are hidden or suppressed.

The femme fatale's hair was her most effective and lethal weapon. Rossetti's passion for women's hair throughout his career was nothing short of an obsession. There are many stories of Rossetti breaking off in mid-conversation at parties, as though hypnotized, when a red-headed woman entered the room, or running through the streets of London in pursuit of a fine head of hair. Both Lizzie Siddal and Jane Morris were remarkable for their beautiful hair. Around 1855, in the illustrations for Moxon's *Tennyson* and the sketch for *La Belle Dame Sans Merci* (where inevitably the seductress winds her hair around her victim's neck), the hair seems to take on an independent expressive life. In late works the heads are bowed down by the weight of the luxuriant tresses which spread out on either side, anticipating the decorative patterns of Art Nouveau. Rossetti's morbid fixation must have been still further heightened by the famous incident when he buried the first drafts of all his early poetry in Lizzie Siddal's coffin, wrapped in her lovely copper-coloured hair. Ten years later, when he disinterred his wife to retrieve the poems for publication, it was found that the volume had become entangled and could not be removed without cutting away the enmeshing locks.

Despite the tragedy of Rossetti's final years, when the collapse of his mental and physical health brought about a disastrous decline in the quality of his work and he lived as a recluse, refusing to exhibit, his influence continued to spread through his many disciples and imitators. The best and most individual of these artists was Edward Burne-Jones. Burne-Jones was also attracted to what he called 'exceedingly mischievous women'. He spoke of 'that sex whom I revere

Top Dante Gabriel Rossetti, *Pandora* 1869. Rossetti's drawing of Pandora, who according to Greek legend brought evil into the world, is an example of the type of female beauty, inspired by the features of Jane Morris, he favoured in the latter part of his career.

Above Dante Gabriel Rossetti, *Lucrezia Borgia* 1860-1.

Opposite page:

Left Edward Burne-Jones, *The Depths of the Sea* 1887. Death by drowning was a common fate for male victims of femmes fatales.

Top right Edward Burne-Jones, *Portrait of Maria Zambaco* 1871. Burne-Jones' drawing of his mistress Maria Zambaco has an intimate and oppressive sensuality that is reminiscent of Rossetti's drawings of Jane Morris.

Below right Aubrey Beardsley, Chapter heading from *Le Morte Darthur* 1893-4. These heads with their prominent chins and bushy hair are a schematic version of the Pre-Raphaelite type.

but with trembling'. Burne-Jones painted a beautiful dream world without ugliness or violence. But it was not a Kate Greenaway world of untroubled innocence and contentment, and it was not without evil, particularly in its feminine manifestations. There is often an underlying malaise, a sense of menace: figures seem to cringe; they are anxious, furtive and helpless; temptresses and evil-doers are quite as withdrawn and uneasy as their victims. Even more disturbing is their passivity and complete lack of expression; like sleepwalkers they gaze into empty space or straight out at the viewer with a haunting ambiguity.

The type of woman that Burne-Jones loved to paint was basically a modification of the Rossetti ideal, refined and purified of Rossetti's sensuality. The women in Burne-Jones' early works are closely modelled on those Rossetti was painting at the same time but as Rossetti's women swelled into an ever more fleshly and mindlessly awesome state, Burne-Jones' figures became increasingly slender, ethereal and fragile. The massive creatures in Rossetti's late works, with their sultry features and ballooning black hair, could hardly be more different from the pallid weightless virgins painted by Burne-Jones. But Rossetti's tendency to blur distinctions between the sexes is taken much further by Burne-Jones. His young women are sexless, androgynous, sometimes barely distinguishable from the beautiful youths that he also liked to paint.

Burne-Jones was a more consistent artist than Rossetti, but neither his art nor his life reached the same level of intensity. He led a life of almost unblemished rectitude and bourgeois respectability. Unlike Rossetti he rarely allowed his life and his art to merge. But one incident has a curiously Rossettian flavour and had a considerable effect upon his work. In emulation of Rossetti's own literary-inspired love affairs, Burne-Jones became entangled with a beautiful and intense Greek woman, Maria Zambaco, who might have stepped out of a painting by Rossetti and had indeed posed for him. Rossetti described the tragi-comic dénouement of Burne-Jones' affair with ironic detachment in a letter to Ford Madox Brown. Maria Zambaco 'provided herself with laudanum enough for two' and insisted upon a double suicide by drowning. She struggled with Burne-Jones on the banks of the Serpentine, until the hapless artist was 'collared' by a passing policeman who had mistaken his intentions.

Burne-Jones used Maria Zambaco's striking features in his painting *Circe the Enchantress* and he painted a portrait of her which has a Rosettian voluptuous intensity and sense of physical presence. In this portrait, he identifies his love with Dante's Beatrice as Rossetti had done with Lizzie Siddal and Jane Morris. The ignominious end of the affair was translated shortly after into the more dignified image of *The Tree of Forgiveness*, in which an unhappy-looking Demaphoön struggles to free himself from the embraces of Phyllis. Sixteen years later, Burne-Jones painted *The Depths of the Sea*, a yet more striking expression of his terror of the suffocating embraces of women. With a look of triumph upon her face, a mermaid pulls the inert body of a man down into the depths of the sea.

An artist who was able to effect a radical and interesting transformation of the Pre-Raphaelite ideal was the illustrator Aubrey Beardsley. Beardsley's early style derived from that of Burne-Jones, but he soon infused it with a conscious decadence and exotic elements borrowed from Whistler and Japanese woodcuts. The illustrations which Beardsley produced for his first important commission, a modestly priced edition of *Le Morte Darthur*, published by Dent with the aim of undercutting the famous version of William Morris and Burne-Jones, were both an homage to and a parody of the older Pre-Raphaelites. Beardsley exaggerated the prominent chins, bushy hair and elongated sexless bodies of the Pre-Raphaelite women to the point of caricature.

All of Beardsley's work is characterized by an ironic detachment. The artist is an outside observer, a voyeur of activities in which he can never participate. This role was forced upon him by the ravages of tuberculosis which precluded an active sex life and were to kill him at the age of 25. As Huysmans said of the quasi-pornographic illustrator Félicien Rops – often compared to Beardsley – 'It is only chaste people who can be really obscene.' With the heightened intensity associated with his disease, Beardsley explored every possibility of perverse eroticism. Among the freaks and monsters who people his drawings,

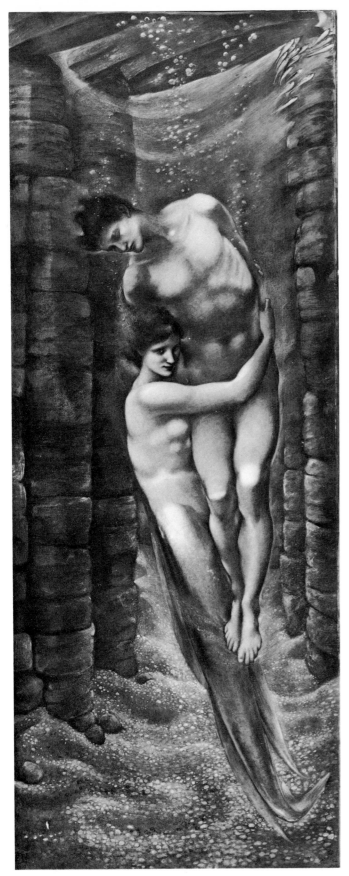

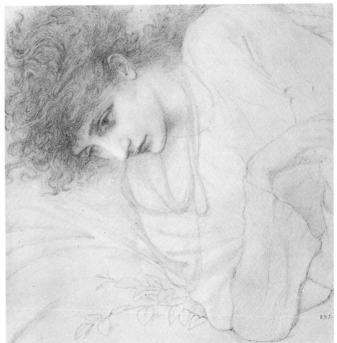

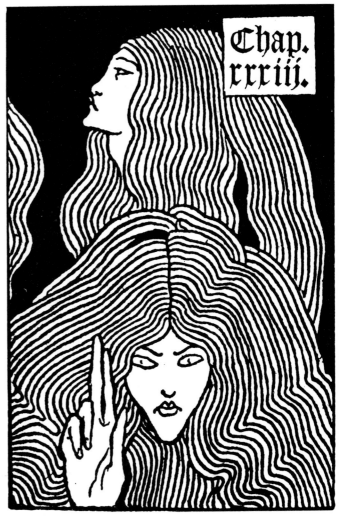

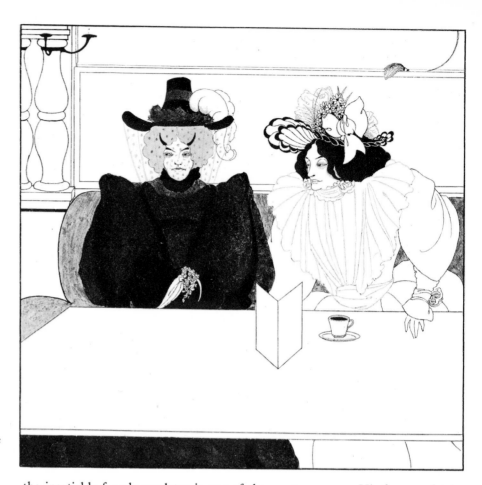

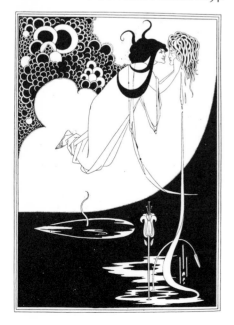

Right Aubrey Beardsley, First frontispiece to *An Evil Motherhood* 1895.

Below Aubrey Beardsley, *The Climax*, illustration to Oscar Wilde's *Salome* 1894.

the insatiable female predator is one of the most common. His femmes fatales are usually bloated and grotesque and have lost their more desirable qualities. Beardsley's school-boy prankishness and his attempts to shock by any means can also be attributed in part to his disease. He knew that time was short and that notoriety was easier to achieve than praise. He delighted in the blasphemous inversion of beauty and morality. Roger Fry called him 'The Fra Angelico of Satanism'.

A commission to illustrate Oscar Wilde's *Salome* gave Beardsley the opportunity for his most notable treatment of the femme fatale theme. Beardsley's designs are the ultimate in mannered and elegant decadence. He took the same cool and wittily irreverent attitude to Wilde that he had taken to the Pre-Raphaelites. The illustrations to the play poke fun at the author and wilfully ignore the text; Wilde hated them. Nevertheless, Beardsley became firmly associated with Wilde in the public mind, much to his embarrassment after the poet's trial and imprisonment for homosexuality. Wilde's *Salome* has been eclipsed by Beardsley's brilliant illustrations and Richard Strauss' operatic setting, but the original play, however fatuous, did give definitive form to a particular type of destructive female: the young girl in whom perversity and virginal innocence are piquantly mixed – the paedophile's femme fatale. With her childish prattle and whimsicality, Wilde's Salome is a diabolical version of David Copperfield's child-wife Dora and forerunner of Lolita and Baby Doll.

Salome was also the subject of the best-known and most characteristic paintings of the French artist Gustave Moreau. He returned repeatedly to the subject, exploring every moment and every aspect of the story. The two paintings of Salome which Moreau exhibited at the Salon of 1876 inspired a passage in Huysmans' novel *Against Nature* which is one of the most famous and typical expressions of the late nineteenth-century idea of the fatal woman:

Here she was no longer just the dancing-girl who extorts a cry of lust and lechery from an old man by the lascivious movements of her loins; who saps the morale and breaks the will of a king with the heaving of her breasts, the twitching of her belly, the quivering of her thighs. She had become as it were, the symbolic incarnation of undying Lust, the Goddess of immortal Hysteria, the accursed Beauty

exalted above all other beauties by the catalepsy that hardens her flesh and steels her muscles, the monstrous Beast, indifferent, irresponsible, insensible, poisoning like the Helen of ancient myth, everything that approaches her, everything that she sees, everything that she touches.

The strange dream world conjured up by Moreau offers interesting parallels with the art of Burne-Jones. There is a similar love of androgynous beauty and an atmosphere of languid passivity. Mario Praz's vivid description of Moreau's work would apply to Burne-Jones almost equally well:

> Lovers look as though they were related, brothers as though they were lovers, men have the faces of virgins, virgins of youths. The symbols of good and evil are entwined and equivocably confused. There is no contrast between different ages, sexes or types. The underlying meaning of this painting is incest, its most exalted type the androgyne, its final word sterility.

The facts of Moreau's life as well as the hostility towards women evident in his paintings tempt one to diagnose a classic Oedipus complex. For most of his adult life, Moreau lived alone with his mother in a large and gloomy mansion in the centre of Paris. When she became deaf, he communicated with her by means of little scraps of paper. After her death, which occurred when he was 58, he was inconsolable, and closed off her bedroom and the dining room where they had eaten together. Apart from his mother and one mysterious and long-lasting sentimental friendship, Moreau seems to have had little time for women except in his macabre fantasies. Some idea of the intensity of Moreau's misogyny can be gained from this commentary on his exquisite watercolour *Salome in the Garden*:

> This bored and fantastic woman, with her animal nature, giving herself the pleasure of seeing her enemy struck down, not a particularly keen one for her because she is so weary of having all her desires satisfied. This woman, walking nonchalantly in a vegetal, bestial manner, through the gardens that have just been stained by a horrible murder, which has frightened the executioner himself and made him flee distracted. . . When I want to render these fine nuances, I do not find them in the subject, but in the nature of women in real life who seek unhealthy emotions and are too stupid even to understand the horror in the most appalling situations.

A sado-masochistic streak in Moreau's psychological make-up is apparent in his many depictions of beautiful youths, dead, dying and mutilated. Next to terrible and monstrous women these were his favourite subjects. The most grandiose of these pictures was *The Suitors*, which he worked on for over forty years. It is based on the account in the *Odyssey* of how Ulysses, returning home from the Trojan Wars, took revenge upon the suitors who had been pressing their unwelcome attentions upon his faithful wife Penelope. The picture is a revealing example of how familiar themes were transformed in late nineteenth-century painting and of how the most unlikely material was used to express a neurotic anxiety about women. The uninformed viewer would be unlikely to identify the literary source of *The Suitors*, which depicts a vast classical interior heaped with the bodies of scantily-clad young men who, in the midst of their death agonies, subside into graceful and voluptuous attitudes – Delacroix's *Sardanapalus* in reverse. The Goddess Athena, appearing as an apparition, at the centre of the picture, seems to be responsible for the orgiastic carnage, rather than the insignificant figure of Ulysses who is dwarfed by the enormous columns in the background.

Moreau was one of the luminaries of the Symbolist movement, which can best be defined in negative terms as a reaction to the materialism of nineteenth-century Europe and to the naturalism which was predominant in the arts in the 1860s and 1870s, and which culminated in the novels of Émile Zola and the paintings of the Impressionists. There was a remarkable diversity of style among the Symbolist painters and they are linked mainly by their choice of subject matter and a shared sensibility.

The everyday world around them was of little significance. Moreau proclaimed, 'I believe only in what I do not see'. Instead they looked inwards and tried to

Henri Rivière, *Herodias* 1896. Salome's mother Herodias was also a frequently depicted femme fatale. This engraving is an illustration to Mallarmé's *Hérodiade*.

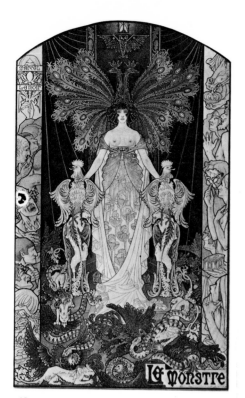

Above Marcel Lenoir, *The Monster*.

Below Félicien Rops, *Calvary*.

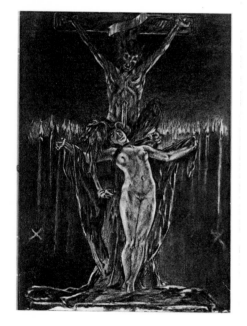

explore the depths of the 'soul' or the unconscious. Imagination was the most prized artistic faculty and the Symbolists gave free rein to their unconscious fantasies. Their paintings often have a dreamlike quality which was also created, later, by the Surrealists. The Symbolists' use of sexual imagery was more personal and more explicit than anything before in European art, and naively self-revelatory in a way hardly possible since Freud and Jung.

Symbolism was an art of ideas closely allied to literature. The best artists found convincing visual equivalents for their ideas and fantasies, but sometimes, as in Marcel Lenoir's *The Monster*, the symbolism is so literary and so complex that it cannot be fully understood without a verbal commentary. Lenoir explained that the idea behind his picture was 'the subjugation of man to woman'. This is shown in the hieratic idol-like pose of the bare-breasted woman. In the left hand border are the distorted faces of the men who lust after her and want to rape her, and in the right hand border are those who revere her and bring gifts; both attackers and worshippers are under her dominion.

The subjugation of man to woman was a very common theme in Symbolist painting. Among those who were under the spell of the femme fatale were the Frenchmen Georges de Feure and Lucien Lévy-Dhurmer, the Belgians Fernand Khnopff, Jean Delville and Félicien Rops, the Dutch-Javanese Jan Toorop and the German Franz von Stuck. Khnopff painted some of the strangest variations on the theme of the sphinx or animal-woman, joining the heads of beautiful women on to the bodies of vultures and panthers. He evolved his own version of the Pre-Raphaelite type of female beauty, inspired by his dead sister whose features recur obsessively in his paintings, rather as those of Lizzie Siddal and Jane Morris do in those of Rossetti.

Khnopff's fellow countryman Delville created one of the most extraordinary images of a femme fatale in his portrait of the wife of the Symbolist poet Stuart Merrill. Her pale and hypnotically intense face materializes from an aureole of fiery red hair. She seems to possess supernatural powers and there are suggestions of the occultism which was so fashionable in Symbolist circles.

The lavish praise accorded to the graphic work of Rops by Symbolist poets and other contemporary literary men now seems surprising. His technique was facile and conventional. His modernity derived partly from a chic satanism, but mainly from his hostility towards women. In 1868, the Goncourt brothers noted in their journal: 'Rops is truly eloquent in depicting the cruel aspect of contemporary woman, her steely glance and her malevolence towards man, not hidden, not disguised, but evident in the whole of her person.' The most interesting aspect of Rops' work now seems his use of consciously blasphemous and pornographic imagery, which in its oddity approaches the surreal.

The femme fatale appears in a more decorative form in the works of De Feure and Lévy-Dhurmer. De Feure's exquisite drawings and watercolours have the linear patterns of Art Nouveau and a flavour of Baudelairean satanism. Lévy-Dhurmer drew a series of portrait-like busts and half-length pastels of such famous seductresses as Eve, Salome and Circe. Their secretive, Leonardesque smiles have a sinister charm.

Toorop's two most famous works, *Fatality* and *The Three Brides*, are reinterpretations of the theme of the three stages of woman, which has a long history in the iconography of Northern European art. His drawings are among the most extreme examples of the fin-de-siècle fascination for women's hair: the tendril-like strands of hair spread to every corner of the picture surface like some uncontrollable fungoid growth. Toorop's Javanese background enabled him to give an authentically exotic flavour to his work.

The enormously successful Franz von Stuck emphasized the animality of women. His women seem to have abundant and insatiable vitality in contrast to the more languid varieties of femme fatale. Stuck's style combined features of Symbolism and Art Nouveau with a gross and earthy realism, resulting in works which are disturbing, shocking or simply ludicrous. He made an international reputation with his representations, using Biblical and phallic associations, of sin, sensuality and vice exemplified by women lasciviously entwined with huge, slimy snakes. The symbolism in these paintings now seems absurdly obvious and they show, as in the case of Rops, how easily the femme fatale theme could slip into quasi-pornographic sensationalism.

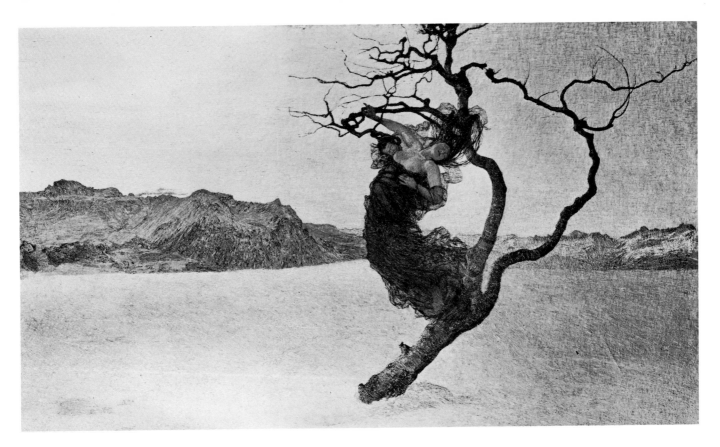

The only Italian Symbolist painter of significance was Giovanni Segantini. In his brief career, he executed several versions of a work entitled *The Wicked Mothers*. These pictures might be interpreted as a warning to the 'new woman' desiring an independent life, freed from the shackles of marriage and mother-hood. The theme of *The Wicked Mothers* is borrowed from an Indian poem, *Pangiavahli*, introduced into Europe by the German philosopher Schopenhauer and translated into Italian by Puccini's librettist Luigi Illica. The passage illustrated by Segantini tells of the punishment inflicted on women who deny their biological role of motherhood.

Two of the greatest painters associated with Symbolism in France, Paul Gauguin and Odilon Redon, run counter to the prevailing trend of misogyny in their attitudes towards women, but even they could not entirely escape its influence. There was something of the Byronic hero about Gauguin. He liked to see himself as savage and dangerous, 'a wolf let loose in the woods', the corruptor of purity. His taste was for innocent young girls rather than for femmes fatales. The painting *The Loss of Virginity* celebrates in somewhat distasteful fashion Gauguin's conquest of the young seamstress Juliette Huet, who was later to bear him a child and received in compensation the gift of a sewing machine. In the relief carving, *Be loving and you will be happy*, Gauguin por-trayed himself as the evil and hideous seducer of a terrified woman.

Of the more obvious femme fatale subjects, the only one which attracted Gauguin was Eve, who seems to have interested him more as an archetype of primeval innocence than as the agent of man's downfall. Gauguin clearly identified Eve with his own mother. In the small painting *Exotic Eve* the head is based on a photograph of his mother, and versions of the same figure appear in the painting *Tahitian Eve* and in several drawings and prints. Some of the women in Gauguin's Tahitian canvases are impressive and mysterious, even awesome. The painting *Queen of Beauty* is a translation into a Tahitian setting of Manet's *Olympia*, a painting which Gauguin enormously admired. The Tahitian woman's confidence in her sexual powers is expressed in her languorous pose, her calm smile and her sly side-long glance.

In the graphic work of Odilon Redon, women share the touching innocence and vulnerability with which he imbued his strange hybrid monsters, fantastic insects and plants and amoeba-like creatures. It is only in the three series of lithographs inspired by Flaubert's *The Temptation of Saint Anthony* that the

Giovanni Segantini, *The Wicked Mothers* (detail) 1894. The wicked mothers are tormented by their unborn babies.

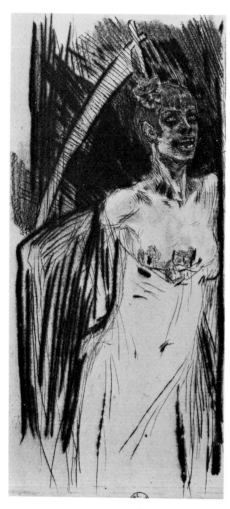

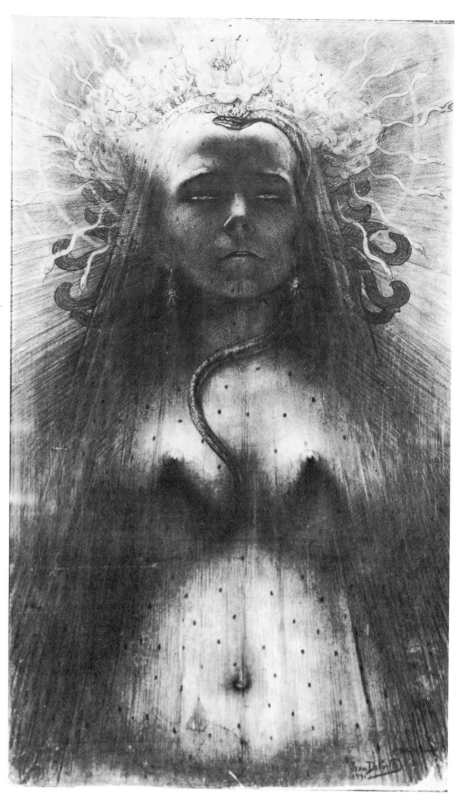

Above Félicien Rops, *Mors Syphilitica*.
Right Jean Delville, *The Idol of Perversity*
1891.
Death, disease and vice were frequently
depicted in female form in the late
nineteenth century.

destructive aspect of women figures more prominently. In *Death: It is I who make you serious*, we find the familiar association of woman's beauty with death, and the two prints entitled *Death: My Irony surpasses all others* closely follow a passage in *The Temptation of Saint Anthony* in which death is described as having a female torso and a skeletal head, crowned with flowing hair.

Painters and writers of the realist tendency were far more restricted in their choice of subject matter and therefore less able to give expression to their personal obsessions and fantasies. Their aim was to depict modern life as they experienced it, in all its banality and ugliness. Fantastic and legendary heroines were of no interest to them. Courbet said he would not paint an angel unless someone brought one to his studio, and would no doubt have said the same of vampires and sphinxes. But the Realists were not immune to the prevalent

anxieties about women. They could find a multitude of evil and threatening women among their contemporaries – especially the prostitutes – from street-walkers to 'Grandes-Horizontales'.

An early and influential example of a realistic femme fatale was Prosper Merimée's coarse and vicious Carmen. Merimée took great care to make her authentic and based the character upon that of a gypsy woman he had encountered in Spain. Carmen was the prototype for many small-time sirens, factory girls, street-walkers, cabaret artists and second-rate actresses in nineteenth- and twentieth-century literature, and she eventually found musical incarnation in Bizet's opera.

The Lady of the Camellias by Dumas fils, first performed as a play in 1852, established a vogue for courtesans in the French theatre. Marguerite Gautier, the Lady of the Camellias, was still a Romantic heroine of the fragile, self-sacrificing kind, but she was soon followed across the boards of the Parisian theatres by courtesans made of much tougher material, inspired by the notorious prostitutes of the Second Empire. Just fifteen years later, Dumas fils himself remarked that ideas and tastes had changed so drastically that it would no longer have been possible or 'true' to write a play with a tragic heroine like the Lady of the Camellias.

The arch-realist, Émile Zola, gave definitive form to the prostitute as femme fatale in his novel *Nana*. Reputedly a portrait of the courtesan Blanche d'Antigny, *Nana* is the story of a prostitute who climbs to the top of her profession leaving a trail of destruction behind her. George Moore described her as 'the Messalina of modern times'. Later fatal women of this more squalid and realistic type include Frank Wedekind's Lulu and Heinrich Mann's Lola-Lola Frolich in the novel *Professor Unrath*, which was filmed as *The Blue Angel* and launched the career of Marlene Dietrich as the most famous screen femme fatale of the twentieth century.

Gustave Courbet, the painter for whom the term Realism was invented, was too much a man of his time to ignore the topical theme of high-class prostitution. His painting *Young Ladies on the Banks of the Seine* was immediately recognised by both critics and public as a portrait of two 'cocottes' (or harlots). The Socialist philosopher Pierre-Joseph Proudhon, who was Courbet's friend and defender, presented an interesting interpretation of this picture. The brunette, he wrote, 'lies full length on the grass, pressing her burning bosom to the ground; her half-closed eyes are veiled in erotic reverie. . . There is something of the vampire about her. . . Flee, if you do not want this Circe to turn you into a beast.' The blonde, thought Proudhon, 'also indulges in fancies, not of love but of cold ambition. She understands business, she owns shares and has money in the Funds. . . Quite different from her friends, she is the mistress of her own heart and knows how to bridle her desires.' But despite Courbet's attraction to the Baudelairean theme of lesbianism or 'femmes damnées', there is nothing very fatal about most of his buxom and rather earthy women.

Manet's *Olympia*, one of the masterpieces of Realist painting, depicts unmistakably and shockingly a modern Parisienne. Olympia descends from a long tradition of reclining female nudes, stretching from Giorgione to Ingres. But, unlike her predecessors, she does not passively offer up her charms for the delectation of the viewer. She presents a striking contrast to the inert and spineless odalisques of Ingres. Olympia's challenging and unmaidenly stare no doubt had a great deal to do with the moral outrage which greeted the picture when it was first shown. The black cat which stands on the end of the bed and which, like Olympia, fixes the viewer with its gaze, brings a touch of Baudelairean *diablerie* and suggestions of black magic and the witch's familiar. Olympia is the Realist's version of the sphinx – or the sphinx divided into its two component parts of cat and woman. The influence of Baudelaire's imagery on Manet's *Olympia*, which was long overlooked, shows how the differences between opposing schools in nineteenth-century French art are rarely as clear-cut as they seem. The Realist painter Manet was bound by close friendship to the Romantic poet Baudelaire and the Symbolist poet Mallarmé, and was certainly influenced by their aesthetic ideas, although at first glance his art would seem to have more in common with that of Zola. There is, in fact, an interesting link between Manet and Zola. Zola was encouraged to write *Nana* by a painting by Manet of a

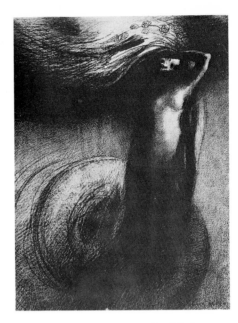

Above Odilon Redon, *Death: My Irony surpasses all others* 1889.

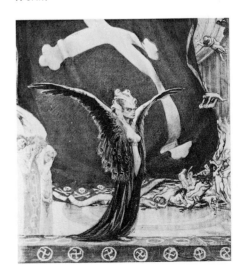

Below François Kupka, *The Conqueror Worm*.

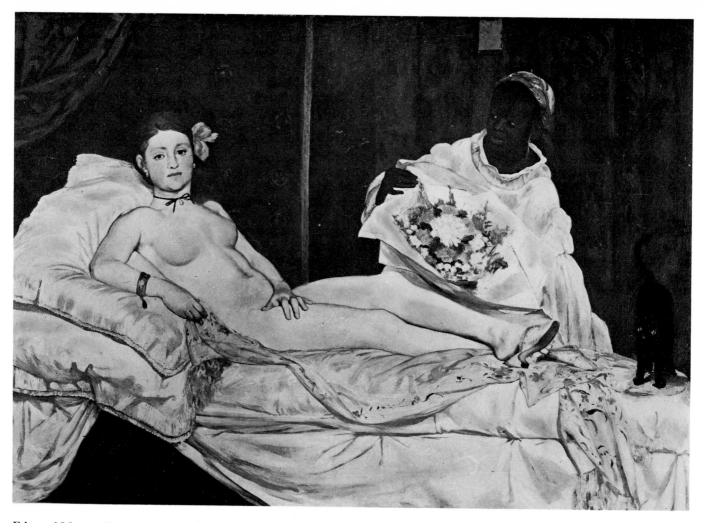

Edouard Manet, *Olympia* 1863. Manet's painting of a self-possessed young Parisiènne caused one of the major art scandals of the nineteenth century.

'cocotte' named Nana who had in turn been inspired by a character in one of Zola's earlier novels.

Even the seemingly objective portrayals of women by Edgar Degas were affected by the pervasive attitudes of the time. Although Degas and Gustave Moreau spent a great deal of time together as students in Italy, an unbridgeable gap seems to separate these two artists. Degas was contemptuous of the fantastic art of his former friend, but he shared the belief that women were amoral, animal-like and philistine. Degas' magnificent series of pastels, in which he depicted women with uncompromising realism in the contorted and inelegant postures of their intimate ablutions in the bath-tub and the bidet, had misogynist connotations for his contemporaries which are no longer immediately apparent. Huysmans reacted with a thrill of horror when he saw these pictures:

> M. Degas, who in his admirable pictures of dancers had so implacably rendered the moral decay of the mercenary female, her mind dulled by mechanical gambollings and monotonous jumping about, has on this occasion, with his studies of nudes, contributed a lingering cruelty, a patient hatred.

Degas, who was notorious for his dislike of women, himself wondered whether he had not gone too far in 'treating women as animals'.

Henri de Toulouse-Lautrec took over much of his subject matter as well as essential elements of his style from Degas, whom he revered as a master. As in the case of Beardsley, the role of detached and ironic observer was forced upon him by his physical disabilities, but it was also one he had inherited from Degas and Manet, who were themselves influenced by Baudelaire's conception of the role of the artist expounded in his famous essay *The Painter of Modern Life*. Lautrec haunted the demi-monde of the cafés, cabarets and brothels, and depicted the women he found there as broken-down *filles de joie*, with tired indifferent eyes, mirthless leers and raddled masks of faces, gashed by the thin red line of vampire-like mouths. His paintings reveal no sense of physical desire for these

women; their ugliness is both sinister and pathetic. There is an element of caricature which again recalls Beardsley. In their different ways these two tragically short-lived artists epitomized the brittle and cynical spirit of the 1890s.

Realistic and symbolic elements are mingled in the work of three great Scandinavians – the playwrights Henrik Ibsen and August Strindberg and the painter Edvard Munch – who attempted to depict the conflict of the sexes and the destructive power of women in a modern bourgeois domestic setting. In the work of these three men the origins of the anxieties which afflicted their age are most clearly discernable, but their attitude towards women and the entire phenomenon of the femme fatale can only be understood when considered in a social and historic context.

In the mid-nineteenth century, women of the middle and upper classes – from which male artists almost invariably came – had few outlets for their creative energies. Even traditional household duties were increasingly precluded for the sake of genteel appearance. Fashionable dress made any kind of useful activity of a practical nature quite impossible. The ideal Victorian wife was a kind of child-woman kept in a state of suspended infantile dependence. Ibsen's play *The Doll's House* shows how the submissive and helpless roles which wives were expected to play could force them into deceit, and his *Hedda Gabler* demonstrates how an intelligent woman could be driven into the most demented and destructive actions out of sheer boredom and frustration.

If the married woman's situation was bad, that of the unmarried woman was far worse and competition for eligible husbands was desperate. Here again women were forced to dissimulate. Although they were instilled from an early age with the belief that marriage was the ultimate goal, women could only set about catching a husband by subtle and indirect means. Naturally enough men felt themselves to be hunted. As Shaw remarked in his preface to *Man and Superman*, 'the whole world is strewn with snares, traps, gins and pitfalls for the capture of men by women'. In Britain the situation was made worse by the fact that throughout the century there was a substantial and increasing majority of adult women. Amongst those who were finally 'caught' must have been many men who found themselves saddled with a charming and decorative parasite whose upbringing had not equipped her for any useful function in life.

Carl Jung believed that it is when man undervalues feminine qualities and mistreats women that the darker aspect of the *anima* manifests itself and he is plagued by fears of evil women. Certainly, the proliferation of femmes fatales in nineteenth-century art, and the curious ambivalence between the sexes, must have some connection with the oppressed and unnatural position of women in society at the time. But the marked increase in male anxiety about women coincided with the first moves towards a significant change in the status of women which took place in the last thirty years of the century. The issue of votes for women was first raised in the British Parliament in 1867. In 1869 John Stuart Mill published his essay on *The Subjugation of Women*, drawing attention to their iniquitous social position. In Britain the Married Women's Property Act, passed in 1870, established minimum legal rights for the wife, independent of her husband, and other laws followed which gradually improved the legal position of women. This was the era of the 'new woman' and educational and professional opportunities were beginning to open up for women. Crippling barriers of prejudice remained, of course, and the reaction of artists and writers to these unsettling developments was somewhat exaggerated considering that, for the time being, changes benefited only a tiny minority of women.

The Doll's House played throughout Europe and America in the 1880s to violently mixed reactions and did much to promote discussion of the emancipation question. Ibsen was turned, rather against his will, into the champion of women's rights. Strindberg, who was vehemently opposed to the emancipation of women, wrote *Miss Julie* expressly to counteract what he contemptuously called 'Nora-morals' after the heroine of *The Doll's House*. Miss Julie is Strindberg's conception of the new emancipated woman. He wrote, 'Miss Julie is a modern character not because the man-hating half-woman may not have existed in all ages, but because now, after her discovery, she has stepped to the front and begun to make a noise.' Strindberg is one of the most extreme examples

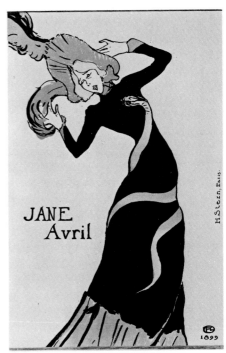

Henri de Toulouse-Lautrec, *Jane Avril*. The cabaret dancer Jane Avril, one of Lautrec's favourite subjects, wears a dress with a modish serpentine motif.

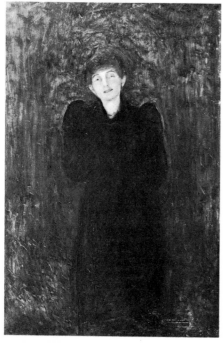

Top Edvard Munch, *Under the Yoke* 1896.
An etching expressing Munch's idea of
the unequal relationship between the
sexes.

Above Edvard Munch, *Portrait of Dagny
Juell Przybyszewska* 1893. Dagny
Przybyszewska was a woman of great
fascination who was loved by both
Munch and Strindberg.

of the almost schizophrenic attitude of many nineteenth-century men towards women. He wrote, 'of all the evil, the worst evil I have ever seen is the female sex: the hindrance, the hatred, the low calculation, the crudity, above all the inhuman threat to a spirit that wants to grow, to rise'. At the same time he assured his friends that his misogyny was 'only the reverse side of my fearful attraction towards the other sex'. He needed women as mother figures and mistresses and at the same time bitterly resented their power over him.

In his treatment of his first wife Siri von Essen, Strindberg alternated between grovelling dependency and arrogant cruelty. While he was still living with Siri, he pilloried her in the most monstrous fashion in his play *The Father* as the character Laura, who deliberately drives her husband the Captain to insanity in an attempt to gain control of their child. It is difficult to feel the sympathy that Strindberg intended for the Captain: Laura is so obviously exaggerated and the Captain is infuriating in his unconscious arrogance and self-pity. He is the only male in a household of females who all contribute to his destruction. He moans, 'It is like going into a cage full of tigers, and if I did not hold red-hot irons under their noses, they might tear me to pieces at any moment.' Later in the play when he is defeated, he begs his wife, 'Don't you see that I am helpless as a child; don't you hear that I am complaining as to a mother?'

The same extremes of feelings towards women – attraction and repulsion, adoration and hatred – are found in the paintings of Strindberg's friend Edvard Munch. In words that could have come from the playwright's pen, Munch described woman as 'the whore who at all times of the day and night seeks to outwit man, to cause his fall'. His etching *Under the Yoke*, which shows a naked woman stretched out sensuously on the grass and a man attempting to enter a narrow, sexually symbolic opening which looks ominously like a medieval instrument of torture, makes it clear that Munch shared Strindberg's view that it is man who is the oppressed and woman the oppressor.

In the early 1890s Munch and Strindberg were members of a wild bohemian circle in Berlin, where they both fell in love with the wife of their friend, the Polish author Stanislaw Przybyszewski. Dagny Przybyszewska was exactly the kind of woman that Strindberg and Munch loved to love and hate. She was capricious and unconventional and in the words of another of her admirers, the art critic Meier-Graefe, 'very slender with the lines of a thirteenth-century Madonna and a smile that drove men to distraction'. Munch painted her portrait in 1893, spectral and sinister. The tangled relationship of the Przybyszewskis and their bohemian friends is reflected in Munch's painting *Jealousy*, in which a haggard and anguished man with the features of Przybyszewski sees in his mind's eye the scarlet-clad figure of Eve offering an apple to another man. Not many years later Dagny Przybyszewska died by the hand of a lover in a game of Russian roulette.

Munch had other involvements with cold and demanding women. His first serious affair, drawn out over six painful years, was with a married woman three years older than himself, who, he said, 'took my first kiss and took from me the perfume of life'. Later there was a certain Tulla Larson who, determined upon marriage with the artist, went so far as to stage-manage a mock death scene, choosing for it a suitably dark and stormy night. When this ploy failed, she pulled a loaded gun and threatened suicide. In the ensuing struggle the gun went off and wounded Munch in the right hand. These melodramas were reflected in Munch's paintings, but with him, as with Rossetti, it is sometimes difficult to disentangle the threads of fantasy, life and art.

Munch equated sex with loss of identity and death. The loss of identity in a moment of passion is most frighteningly evident in the several versions of *The Kiss*, in which the facial features of the two lovers are obliterated in 'a puddle of melted flesh' as Przybyszewski describes it. 'The fusion of two beings, one of which, in the form of a carp seems to be about to swallow the larger after the manner of vermin, microbes, vampires and women', was Strindberg's comment on the painting; but this was to give it a more explicitly anti-female meaning than Munch possibly intended.

On three occasions Munch depicted himself as the lifeless and mutilated victim of a woman's embrace. In the etching *Vampire* his emaciated torso is gripped in the claws of a winged monster with a female torso and head. The

lithograph *Salome* contrasts Munch's grim features with the ecstatic and triumphant expressions of the woman who enfolds his disembodied head in her hair. Finally there is the painting, done in 1906, oddly entitled *The Death of Marat*. Munch had little regard for the historical facts of the death of the French revolutionary leader. He uses it as a metaphor for the spiritual death suffered by man as the result of his sexual union with woman. Munch identifies with Marat, whose naked body lies on the blood-soaked sheets of a bed, while the woman, also naked, confronts the viewer with knife in hand.

The core of Munch's work is a series of paintings executed over many years to which he gave the collective title *The Frieze of Life*. The series includes *Madonna*, *Vampire*, *Jealousy*, *The Three Stages of Woman* and *The Dance of Life*. Munch described *The Frieze of Life* as 'a poem of life, love and death' and intended it to be a grand philosophical statement. He expressly denied the influence of Strindberg, but whether or not he was directly influenced by the playwright, the affinity between them is clear. Their common belief in the overwhelming power of woman's sexuality and her deep-rooted instinct to procreate runs as a *Leitmotif* through the series.

This belief is most clearly expressed in the lithograph made after the painting *Madonna*. *Madonna* is a kind of Darwinian *Liebestod* in which the woman dies a triumphant and ecstatic death in fulfilling her role as mother and continuing the species. The picture shares with other nudes of European tradition the assumed presence of a male viewer, but here the viewer is involved with the subject in a different, more particularly disturbing fashion: the woman confronts the viewer as a sexual partner. In his commentary on the picture, Munch addressed the woman:

It is the moment when all the world stands still. . . Your face contains all earth's beauty. Your lips, crimson red like your ripening fruit, glide from each other as if in pain. . . A corpse's smile. . . New life shakes the hand of death. The chain binding the thousand dead generations to the thousand generations to come is linked together.

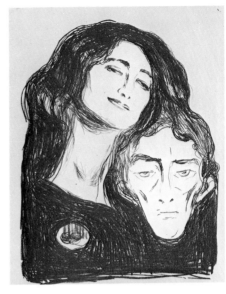

Above Edvard Munch, *Salome* 1903. Munch drew himself as the decapitated victim of his mistress, the violinist Eva Mudocci.

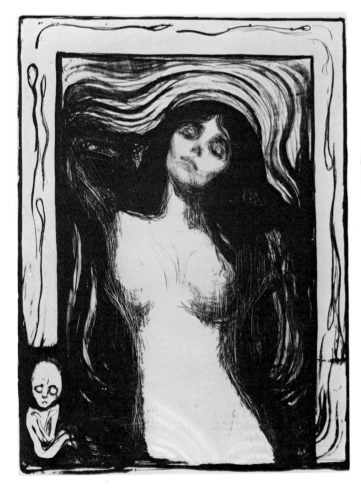

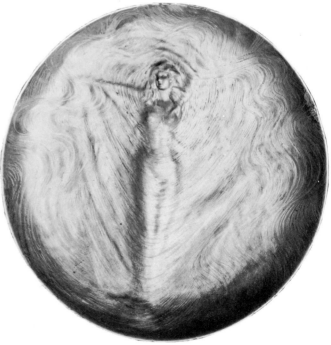

Left Edvard Munch, *Madonna* 1895–1902.
Right Clément Massier, *Iridescent plaque* c. 1898.
Munch's depiction of ecstasy in death ressembles Massier's typically Art Nouveau motif in which arms and hair merge into a swirling ectoplasmic halo.

In the eyes of Munch, woman's physical death is a fate less dire than the spiritual death of man in the mating of the sexes. She achieves a kind of immortality in the conception of a child – which in the lithographic version of *Madonna* is shown as a death's head apparition in the bottom left-hand corner of the composition. According to Strindberg, it is woman's ability to give birth which, together with her lack of moral scruple, gives her superiority in the battle of the sexes. Munch interpreted the mother's role more positively. Her determination to ensure the continuation of the species, and her willingness to undergo pain and the risk of death in childbirth, endow her with a heroic and moral strength beyond the reach of man. Shaw expressed a similar idea in the preface to *Man and Superman*: 'When the terrible moment of birth arrives, its supreme importance and its superhuman effort and peril, in which the father has no part, dwarf him into the meanest insignificance.'

The woman in *Madonna* floats at the centre of a vortex of swirling lines. She merges into and is engulfed by the surrounding space. In this way she becomes yet more threatening, seeming to partake of the life-giving force of nature. The ectoplasmic halo through which the woman seems to merge into her surroundings is a common feature of painting and sculpture at the turn of the century, used to suggest woman's primitive power, her oneness with nature and the way in which she can draw to her and absorb everything around her.

Vampire is more concerned with woman's insatiability and destructiveness. The picture received its title from Przybyszewski. It was not meant as a literal representation of a vampire but rather as an image of the supposedly vampire-like qualities of women. The woman pulls the man to her breast in a maternal embrace. As she leans over his passive form her lips touch the back of his neck, and her hair, which is almost blood red, streams down over his head. Like Rossetti, Munch was alert to the fascination of women's hair and to its sinister and erotic possibilities.

Two related pictures, *The Dance of Life* and *The Three Stages of Woman*, make use of traditional Northern iconography. Munch presents us with the innocent, the sensual and the spiritual woman – or the virgin, the whore and the nun. In both pictures, it is the sensual woman who occupies the central space. In *The Dance of Life* man is caught in the embrace of the sensual woman whose flaming red dress swirls around his feet. In *The Three Stages of Woman*, the man turns away from the woman, blood pouring from his thigh.

Munch and Strindberg remained on terms of troubled intimacy until Munch executed a lithographic portrait of Strindberg which offended the author. In a decorative border Munch printed the word 'Stindberg', dropping the letter 'r'

Félix Vallotton, *The Beautiful Tie-pin* 1898. A subtle undertone of vampirism pervades this woodcut by Vallotton.

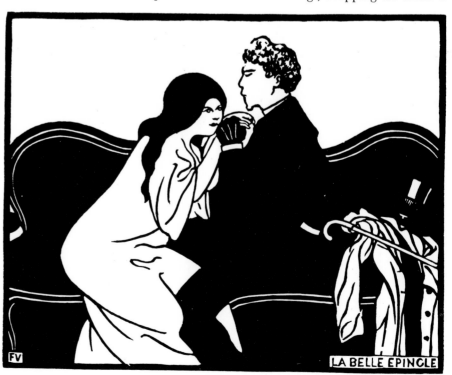

from the author's name and so creating in Swedish the scatalogical double meaning 'mountain of shit'. Even more outrageous to the playwright was the fact that in the same border Munch had placed threateningly close to Strindberg's head the provocative figure of a naked woman.

Despite the isolated and provincial character of the Scandinavian countries in the nineteenth century, Ibsen, Strindberg and Munch, with their psychological incisiveness and harsh introspection, were able to explore more profoundly than any of their contemporaries, albeit from a subjective and often distorted viewpoint, the problems and anxieties of their age. In German cities and many other European centres their work had an explosive impact and everywhere a revitalising effect. The Théâtre de l'Oeuvre, which staged the first French performances of the Scandinavian playwrights, involved many leading artists in its productions, including Munch and the French painter Edouard Vuillard, whose claustrophobic interiors convey a sense of implicit domestic drama.

The work of Vuillard's close friend Félix Vallotton also shows an affinity with Strindberg's plays. The battle of the sexes is the theme of a masterly series of woodcuts entitled *Intimacies*. In these scenes of confrontation, it is again woman who appears as the stronger and more ruthless of the sexes. The most Strindbergian of the series is *The Triumph* in which a man collapses weeping before a woman who sits with folded hands, and stares ahead unmoved, implacable. In *The Beautiful Pin*, Vallotton introduces a suggestion of vampirism more subtly than Munch: the woman leans forward with an expression of intense concentration as she attaches a cravat pin at her companion's throat.

The femme fatale was ushered into the twentieth century by the Viennese artist Gustav Klimt. Although his works retain a certain fin-de-siècle aspect of luxuriant decadence, Klimt is remarkably modern in the frankness with which he explores sexuality. His female nudes display their sex triumphantly instead of attempting concealment, as even the brazen *Olympia* had done. No artist before Klimt had taken such unashamed pleasure in the depiction of pubic hair or the ripe curves of a pregnant torso. Klimt's women are sexual beings. They anticipate and take their pleasure with a frightening intensity. They are the antithesis of the myth of the Victorian wife who passively endures the embraces of her husband.

Klimt's preoccupation with sex, so openly and consciously expressed in his paintings, might suggest the influence of his fellow citizen and slightly older contemporary, Sigmund Freud, whose early pioneering work, *The Interpretation of Dreams*, was published at the end of 1899. Klimt, who was no intellectual and possessed few books, is not likely to have read Freud's book, which achieved a very limited circulation, but he may have heard of Freud's theories from his friends among the wealthy Jewish intellectual bourgeoisie from which many of his patrons came. Sexual questions were much discussed in liberal literary and intellectual circles in Vienna at this time.

Klimt used ornament and decorative shapes in a highly original way to convey erotic meaning. In *The Kiss* the lovers embrace within a golden halo which is at the same time phallic and womb-like, an emblem of sexual union. The merging of the forms of the two lovers conveys sexual ecstasy rather than loss of identity as in Munch's picture of the same title. The patterns of long rectangular shapes on the man's robe and of circles and spirals on the woman's can also be interpreted as male and female symbols. Klimt made similar use of ornament in his magnificent female portraits, and even his landscapes burgeon with tumescent and suggestive shapes. In a number of flowery landscapes which Klimt painted in the years before the First World War, the whole of nature bursts forth into a delirious profusion of erotically charged ornament.

Klimt's obsession with female sexuality gives to his sumptuous portraits of wealthy women an expressive power and intensity absent from most fashionable portraiture. One of the most spectacular is the portrait of Adele Bloch-Bauer, done in 1907. The sitter's ascetic hands contrast with the heavy-lidded sensuality of her face. A claustrophobic profusion of flat gold and silver ornament surrounds the face and hands, giving the picture a curiously Byzantine air; it is more like a religious icon than a society portrait. Klimt abandoned the use of gold and silver in a second portrait of Adele Bloch-Bauer painted in 1912, but it retains the hieratic quality of a religious image. Adele Bloch-Bauer stands frontally at

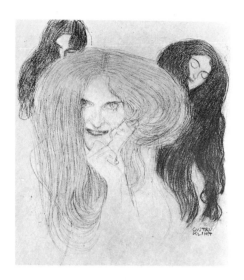

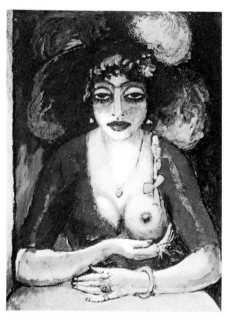

Top Gustav Klimt, Study for *The Beethoven Frieze* c. 1902.

Above Kees van Dongen, *Femme Fatale* 1905.

the centre of the picture. Her hat forms a dark halo round her head and her stole hangs down on the floor, suggesting the vestments of a priestess or a saint.

There is a striking similarity between such portraits and Klimt's 1901 version of *Judith*, in which the theme of sexual power and triumph is essentially the same, though even more explicitly expressed. Judith is transformed from a patriotic Jewish widow into a terrifying fiend who achieves sexual fulfilment through the decapitation and death of her lover. Her lips are parted and her eyes half-closed in ecstasy. Klimt paints the figure close to the picture plane, giving both Judith and the ghoulish head a physical immediacy and an alarmingly portrait-like presence.

Femmes fatales float ecstatically and menacingly through space in the great allegories of *Jurisprudence*, *Medicine* and *Philosophy* which Klimt painted for Vienna University, and under water in the paintings *Moving Water* and *Sea Serpents* where they are suggestively entwined with snakes and spermatazoic water-weeds. They make an appearance in *The Beethoven Frieze* as the powers of darkness and in two allegorical paintings related in theme to Munch's *Frieze of Life*: *The Three Ages of Woman* and *Hope*. Like *Madonna*, *Hope* presents a cyclic view of life in which the female figure is at the centre of the process of birth, procreation and death; a fiery-haired pregnant woman appears against a background of symbolic death's heads.

Klimt was the last major painter for whom the femme fatale was a central theme. After 1900, the fatal woman appeared increasingly rarely in the work of more advanced painters. Until 1901 she was depicted frequently in the work of the young Picasso, which at this time showed influences from artists as diverse as Rossetti, Beardsley and Lautrec. In 1905 Kees van Dongen refurbished the fatal woman in the brilliant colours of Fauvism in a painting entitled simply *Femme Fatale*. The fin-de-siècle survives, surprisingly, in the lurid painting *Modern Idol* by Umberto Boccioni, one of the leaders of the Futurist movement, which eagerly embraced the technological ideals of the new century and rejected the subtleties of Symbolism with the slogan 'Kill the Moonlight!' There have been major twentieth-century painters, such as Gustave Moreau's pupil Georges Rouault and the Dutch-American Willem de Kooning, who have painted awesome and terrifying images of women. But the women of Rouault and De Kooning are without the glamour usually associated with the femme fatale. They have a crude earthiness more reminiscent of the idols of primitive religious cults than of the sophisticated women of the *belle époque*.

The downfall of the femme fatale was hastened by her astonishing popularity. By the end of the nineteenth century, the femme fatale was a stock cliché in art and literature, often cheapened almost beyond recognition. This trivialisation, combined with changing social conditions, eventually discredited her in the eyes of serious artists. The subject was repeated *ad nauseam* by the hordes of artists exhibiting in the Salons and Academies of Europe, always eager to latch on to a fashionable theme and to water down the innovations of more radical artists for easy public consumption. Artists such as Georges Rochegrosse treated fashionably Symbolist and decadent subject matter in a basically academic style, tempered by the influence of Realism and photography. Even such orthodox traditionalists as Jean-Léon Gérôme and Alexandre Cabanel had their popular successes with femme fatale subjects. For the Salon of 1887 Cabanel produced a painting entitled *Cleopatra trying out poisons on her lovers*. Accompanied by a panther, Cleopatra reclines elegantly on a lion skin and watches the death agonies of her former lovers with an expression of supreme boredom.

Fashionable portraiture was also strongly influenced by the cult of the fatal woman. In the early and mid-nineteenth century artists painted portraits of women in languid and submissive attitudes, emphasizing sloping shoulders and rounded boneless limbs. In the sophisticated portraits of the end of the century by such artists as John Singer Sargent, Giovanni Boldini, Jacques-Émile Blanche and Antonio de La Gandara, women are posed in erect and haughty stances. They fix the viewer with a challenging glance, often from beneath half-closed lids. Thin red lips and blackened eyes are conspicuous in faces of deathly pallor. The expression is one of anticipatory pleasure, the lips parted in a confident smile that is both threatening and mysterious; the overall effect one of disconcerting self-possession.

Antonio de La Gandara, *Portrait of Ida Rubinstein*. De La Gandara painted the famous dancer looking fashionably evil.

Franz von Lenbach, *Self-portrait with his family* c. 1903. Lenbach painted his wife and daughters with the malevolent and knowing expressions common in fashionable portraiture at this time.

In the family self-portrait by the successful Munich portraitist Franz von Lenbach, his wife and daughters outstare the viewer with unnerving malignancy. Lenbach's younger daughter is already a fully-fledged little femme fatale. One wonders what Lenbach's feelings were towards womankind in general and towards his wife and daughters in particular, and it comes as no surprise that in another painting Lenbach, like Munch, used his own features for the head of John the Baptist, carried off on Salome's platter.

The clothes worn by fashionable women at the end of the century emphasized height and created an impression of Amazonian vigour and power. Abundant hair was piled up on top of the head and crowned with exaggerated and elaborate head-gear, often adorned with dead birds and fruits and hung with veils. Enormously puffed up sleeves, sometimes as wide as the torso itself, broadened the upper part of the body and accentuated the shoulders. Narrow skirts increased this emphasis and allowed more mobility than women had enjoyed in the constricting crinolines of the mid-century. Breasts were moulded by stays and padding into a pigeon-chested form with no suggestion of feminine pliancy. Voluminous snake-like feather boas added still further to the effect of awesome amplitude. In the drawings of Charles Dana Gibson and other fashionable illustrators of the time, women tower over their insignificant menfolk.

Jewelry also offers insights into the image that women wished to project – or that men wished them to project. In this period jewellers reached unparalleled heights of virtuosity but the subjects at which they excelled, such as stinging insects or writhing snakes, were of a decidedly sinister allure. These spiky, reptilian ornaments, attached to fashionable bosoms, must have been highly uncomfortable to the wearer and dangerous to the man bold enough to risk an embrace. Some of the most spectacular jewelry by René Lalique and his imitators joins insect and reptile wings and limbs on to female heads and torsos, precious counterparts of the hybrid monsters of Symbolist painters. Even in the simpler and less pictorial pieces by Art Nouveau jewellers there is often a slightly gruesome element, the metal melted and polished into soft fleshy or ectoplasmic forms, swelling around the inset jewels which are smooth and rounded, like glistening drops of fluid oozing from a wound.

Top Charles Dana Gibson, *Design for wallpaper suitable for a bachelor apartment* 1903. A generation of young American women modelled themselves on the 'Gibson Girl', a healthy New World cousin of the femme fatale.

Left Hand ornament designed for Sarah Bernhardt by Alphonse Mucha.

Above René Lalique, *Dragonfly Brooch* 1898. Another striking piece worn by Bernhardt.

Left Artus van Briggle, *Lorelei Vase* c. 1900. The Lorelei was a siren who lured sailors to their death on the river Rhine. The merging of the female form into the fleshy womb-like shape of the vase is typical of Art Nouveau.

Centre Bronze dish with the head of Cléo de Mérode, the 'première danseuse' of the Paris Opera and self-styled 'friend of kings'.

Right Sarah Bernhardt, Inkwell, 1880. Bernhardt was herself an amateur sculptress of considerable talent. This strange and macabre inkwell is a rare instance of a femme fatale image being used by a woman artist.

Opposite page:

Above left Dante Gabriel Rossetti, *Beata Beatrix* c. 1863. The attitude of Lizzie Siddal provided a prototype for many later images of femmes fatales.

Above right Alphonse Mucha, Poster for Job cigarettes, 1896.

Below left Gustav Klimt, *Judith* 1901.

Below right Marlene Dietrich used similar poses in publicity photos of the 1930s.

The female faces and forms seen everywhere in Art Nouveau decoration are still clearly related to the Pre-Raphaelite ideal. They are rarely specifically 'fatal', but they are often siren-like, with many of the physical features of the femme fatale – in particular the entangling luxuriant hair, which lent itself well to the linear arabesques of Art Nouveau and the tendency to merge into and engulf the surrounding forms. But the Art Nouveau woman lost some of her predecessor's threatening power and became, in many cases, merely decorative. An example of this transformation of a prototype can be seen in Mucha's poster *Job*. The physical type and the pose, the head thrust back and the eyes half closed in ecstasy, derive from Rossetti's *Beata Beatrix*. The Rossettian formula which had been used to create so many powerful images of female sexuality, is now used to advertise cigarettes.

The concept of the femme fatale permeated through a wide range of popular literature, from illustrated children's books to pornography. The angry and sadistic woman meting out punishment to the helpless male in the form of flagellation is a stock theme of Victorian pornography; and illustrators of children's books such as Walter Crane, Arthur Rackham and Edmund Dulac introduced the Pre-Raphaelite ideal of female beauty into the nursery. Since its publication in 1887, many children have had their first literary experience of the femme fatale in H. Rider Haggard's *She*, a novel full of the kind of half-conscious sexual symbolism possible only in an age of pre-Freudian innocence, and which can be interpreted as an allegory of man's ordeal in the face of threatening female sexuality.

In the years before and after the turn of the century, the cultural scene in Europe was illumined by a number of charismatic women. They were famed more for their glamour than for their other talents, great though these sometimes were. Most were actresses, dancers or singers, though a few, such as the Marchesa Casati and the Princess Belgiojoso, could be termed professional femmes fatales, who had no other goal than notoriety. These women were a great inspiration to the artists of their age, but it was a case of life inspired by art. The actresses, dancers and singers enthusiastically adopted an image which had been created for them by artists and poets.

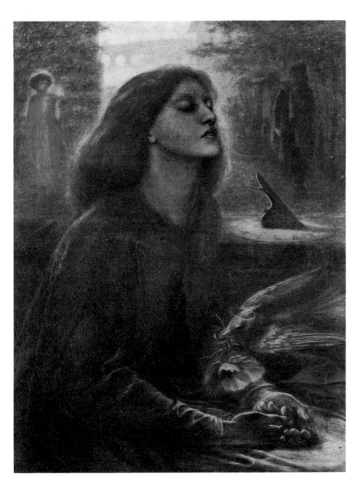

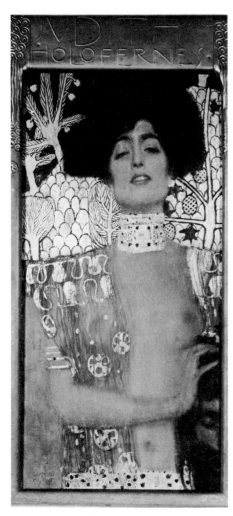

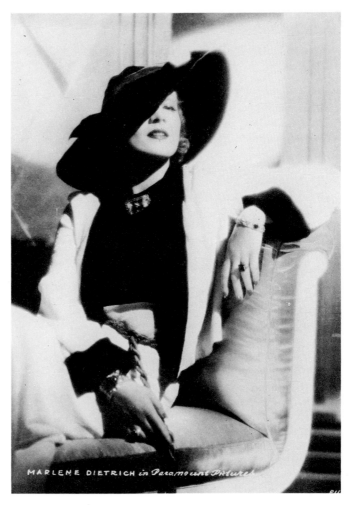

MARLENE DIETRICH in Paramount Pictures

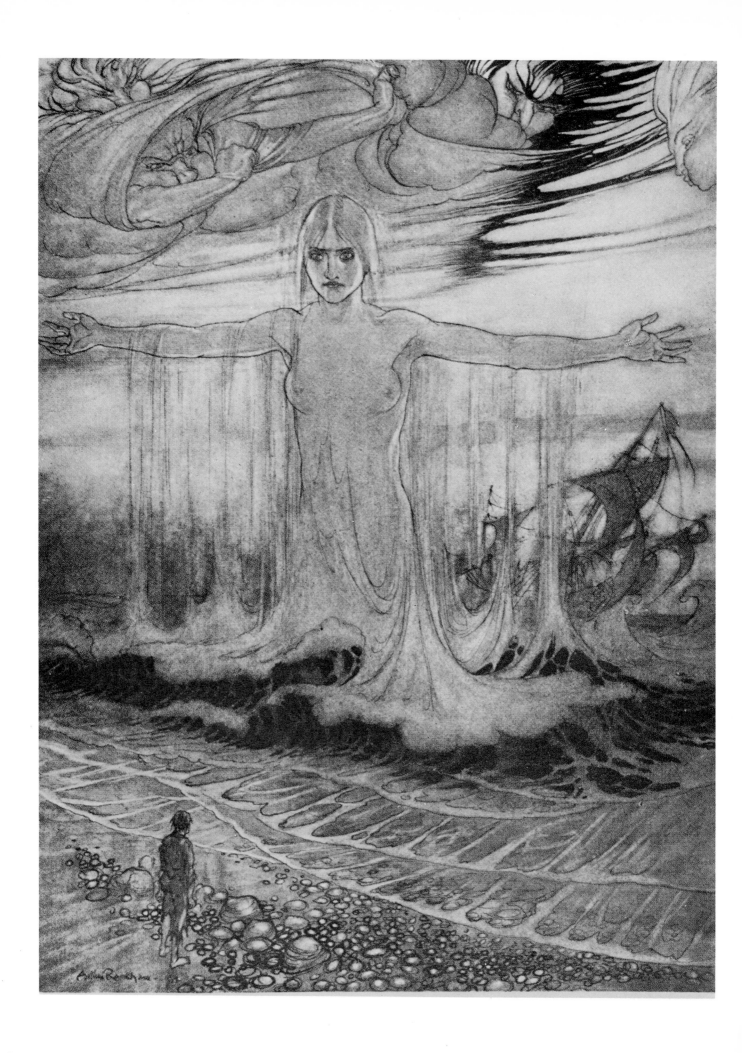

Far left Arthur Rackham, *The Shipwrecked Man and the Sea*, illustration to *Aesop's Fables* 1912. A frightening image of woman as an overwhelming force of nature by one of the most popular illustrators of children's books.

Top Franz von Stuck, *The Sphinx* c. 1895. Stuck eschews the hybrid cat-woman combinations of Khnopff and other Symbolist painters and instead suggests the predatory and inscrutable qualities of woman by means of the pose.

Centre Colette.
Below left Ida Rubinstein
The novelist Colette and the dancer Ida Rubinstein adopted sphinx-like poses for these pin-up pictures of the early 1900s.

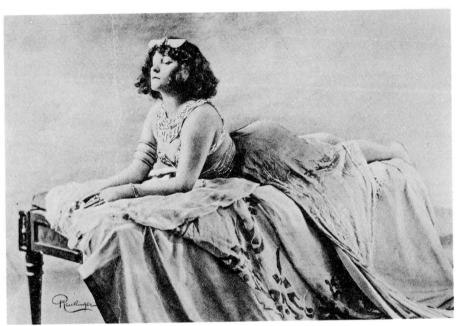

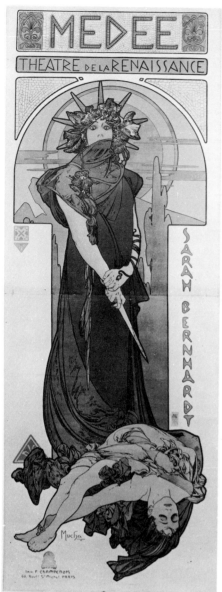

The most famous actress of the age was Sarah Bernhardt, who played the role of femme fatale to the hilt in her much publicised private life. Her scandalous love affairs, the Byzantine luxuriousness of her surroundings, her ever-attendant menagerie of wild beasts, the famous satin-lined coffin in which she was reputed to sleep, her interest in executions (she attended a hanging in London, a garroting in Madrid, and two beheadings in Paris) and her necklace of petrified human eyes, were all part of a carefully cultivated image. Victorien Sardou, who wrote a series of meretricious plays designed to exploit Bernhardt's flamboyant personality, said, 'If there's anything more remarkable than watching Sarah act, it's watching her live.'

Among the dancers were Loie Fuller whose swirling veils were the delight of Art Nouveau artists, and Ida Rubinstein – a lovely and wealthy Russian who, despite very limited ability as a dancer, was able to hold the stage, in ballets produced for her by Diaghilev, by force of personality and sex appeal, reinforced by Bakst's extraordinary costumes. The high point of Rubinstein's career came when Debussy, D'Annunzio and Bakst collaborated in the creation of *The Martyrdom of Saint Sebastian* – a vehicle for her androgynous and consciously perverse beauty.

In opera, elephantine prima donnas were superseded by a generation of sopranos of dazzling beauty, with wasp-waisted figures: Sybil Sanderson, Lina Cavalieri, Mary Garden, Emma Calvé and Aino Ackté. They were able to look convincingly seductive in the new operas of Georges Bizet, Jules Massenet, Camille Saint-Saëns, Giacomo Puccini, and Richard Strauss, which required more than beautiful voices.

The femme fatale arrived late on the operatic stage, but she survived there longer than in other art forms. She continued to inspire operas of enduring quality and great imaginative power well into the twentieth century, after the more serious writers and painters had abandoned her to the hacks and the film industry. Two of the earliest and most influential operatic femmes fatales were Carmen in Bizet's opera, which belatedly introduced Realism to the operatic stage in 1875, and Kundry in Wagner's *Parsifal*, which established a type of religio-eroticism which was fruitfully exploited by Massenet, Strauss and numerous minor composers now forgotten.

Above Alphonse Mucha, Poster for *Medea* 1898. Mucha established his reputation with a series of posters of Sarah Bernhardt in her different roles. Here he has chosen the most horrific moment in the story of Medea, when she murders her children in order to avenge the faithlessness of Jason. Bernhardt wears the reptilian armlet which Mucha himself designed for her.

Right Jean-Léon Gérôme, *Sarah Bernhardt*. This polychrome bust of Sarah Bernhardt by the academic painter Gérôme has the gruesome aspect of a wax dummy.

Left Sarah Bernhardt taking a nap in her famous satin-lined coffin.

Below Romaine Brooks, *The Passing* 1911. At the height of her success, Ida Rubinstein fell in love with the American artist Romaine Brooks, who painted this eerie portrait of her. Romaine Brooks was exceptional among women artists in endowing her female subjects with sinister characteristics.

Above Aino Ackté as *Salome*. The beautiful Finnish soprano sang the title role in Strauss' opera in the London première of 1910.

Right Léon Bakst, Costume for Ida Rubinstein as *Salome*. This costume was not for Strauss' opera but for Florent Schmidt's ballet, *The Tragedy of Salome*. Bakst fleshed out the androgynous Mme Rubinstein with feminine curves she did not possess in contemporary photographs or in the paintings of her lover, Romaine Brooks.

The three most successful operatic composers at the turn of the century, Massenet, Puccini and Strauss, all wrote operas in which fatal women are central characters. Massenet far outstripped his rivals in the sheer number of seductive and destructive women he managed to celebrate in his music. The most popular has been *Manon*, a young femme fatale of singular charm. The familiar equation of love and death runs through nearly all of Puccini's operas. Puccini was temperamentally attracted to women victims rather than women predators. The mental and physical sufferings of his heroines inspired his loveliest and most deeply felt music. But Tosca, with her jealous rages and her cry – 'This is the kiss of Tosca' – as she plunges the knife into her tormenter's chest, has unmistakably fatale characteristics. Puccini's most impressive femme fatale is the icy Princess Turandot, the protagonist of his final opera, which was left unfinished when he died in 1924. Like the sphinx, Turandot poses riddles to her suitors and has them beheaded when they cannot answer. Puccini's score

ends with the self-inflicted death of the slave girl Liu, who dies while being tortured on the orders of Turandot. This scene is reminiscent of a tragic incident which deeply affected the composer. The touching character of Liu is probably Puccini's tribute to the servant girl Doria Manfredi, driven to suicide by the persecution of Puccini's wife, who wrongly suspected her of having an affair with the composer.

By a curious coincidence both Puccini and Strauss were married to women who were notorious for their domineering behaviour, and both wives found their way into their husbands' operas. Elvira Puccini, who was not above doctoring her husband's coffee with anti-aphrodisiacs when he received visits from attractive women, made his life a misery with her neurotic jealousy. Strauss seems to have delighted in the peculiarity of his formidable wife. His blithe portrayal of her as an aggressive harridan in his autobiographical opera *Intermezzo* would today surely be grounds for divorce.

Like Puccini's *Tosca*, Strauss' *Salome* originated in a play written for Sarah Bernhardt. Strauss himself pointed to the affinity between his glittering score and the paintings of Gustav Klimt. It was very important to Strauss that the soprano look the part. What he wanted, he said, was 'a sixteen-year-old with the voice of Isolde'. He was not at all happy with the stolid appearance of the first Salome, Marie Wittich, whom he referred to as 'Aunty'. But the part was a magnificent opportunity for those sopranos with voices strong enough to make themselves heard over the massive orchestration, and figures supple enough to perform the 'Dance of the seven veils'. Strauss's second 'shock' opera, *Elektra*, has the magnificent character of Clytemnestra, a femme fatale of the grotesque aging type depicted so often by Beardsley and Lautrec.

In the inter-war period, in addition to Puccini's *Turandot*, there were Strauss' *Egyptian Helen*, the 342-year-old Emilia Marty in Janacek's *Macropolos Case* and Alban Berg's *Lulu*, based on Wedekind's plays. By this time opera, like the femme fatale, was becoming anachronistic. *Turandot* was one of the last operas to win a firm popular place in the repertory. The last refuge of the femme fatale was in a new art form distantly descended from opera, the Hollywood film. In the 1920s, exotically clad vamps such as Theda Bara, Barbara La Marr and Pola Negri had great box office successes; in the 1930s, Marlene Dietrich and Greta Garbo cultivated the mysterious impassivity and the hint of androgyny characteristic of the fatal woman.

From Baudelaire to Marlene Dietrich is a time-span of more than 75 years. During this period the cult of the femme fatale spread throughout the civilised world affecting painting, sculpture, illustration, the decorative arts, the performing arts, literature – both popular and esoteric – fashion and no doubt the thinking and behaviour of ordinary men and women. It would certainly be illuminating to apply the knowledge of modern psychology to the personalities of Baudelaire, Swinburne, Rossetti, Moreau, Munch, Strindberg and Klimt, to look for common psychological factors and to trace the origins of their attitudes to women to the neuroses born of childhood experiences. But the phenomenon of the femme fatale was far more than the artificial creation of a small number of artists who had problems with their mothers and mistresses. These men sensed and expressed the underlying anxieties of the age, which resulted from profound social changes.

Before the Women's movement had made women conscious of their subservience and given voice to their grievances, poets and artists had realised that male dominance, which had endured since the beginning of civilisation, was becoming increasingly precarious. The first phase of the struggle ended with the enfranchisement of women. After an interval of more gradual change, the pace has again quickened. The reluctant and anxious male is once more under siege. What is left of his dominance is increasingly threatened and undermined. In the meantime women have become more articulate and men can no longer give vent with impunity to their fears and prejudices. Whatever the outcome of the struggle it will not be recorded in the art of our age with the partiality of the nineteenth century. In the painting and poetry of the nineteenth century the femme fatale endures as one of the most powerful images of a troubled age. But in the present period of social revolution she is no longer, as she was for Pater, 'the symbol of the modern idea'.

Top Maria Jeritza as *Turandot*. The brilliant voice and glamorous personality of the Viennese soprano were an inspiration to Puccini when he wrote his last opera.

Above 'The Vamp'. Theda Bara in a publicity pose of 1918 makes the most of her abundant hair.

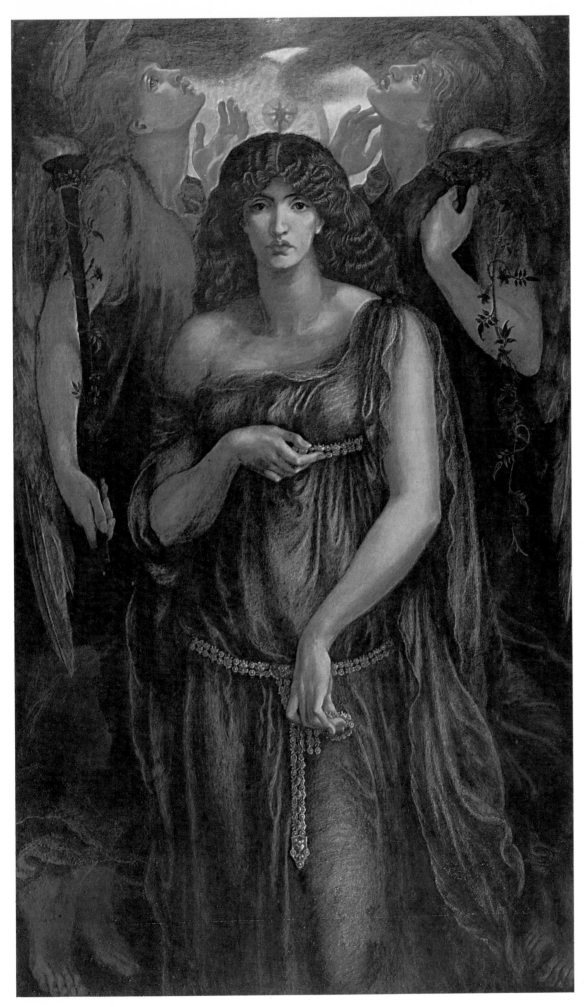

1

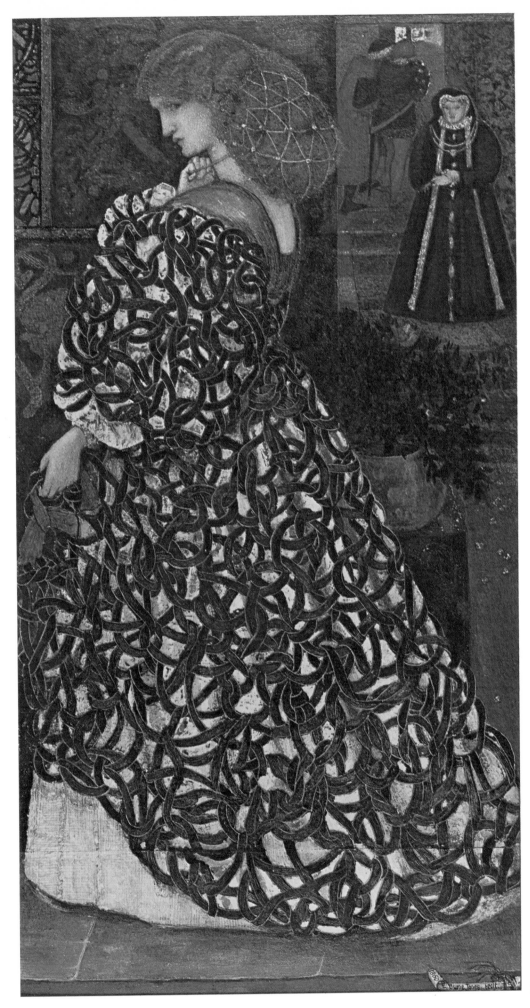

2

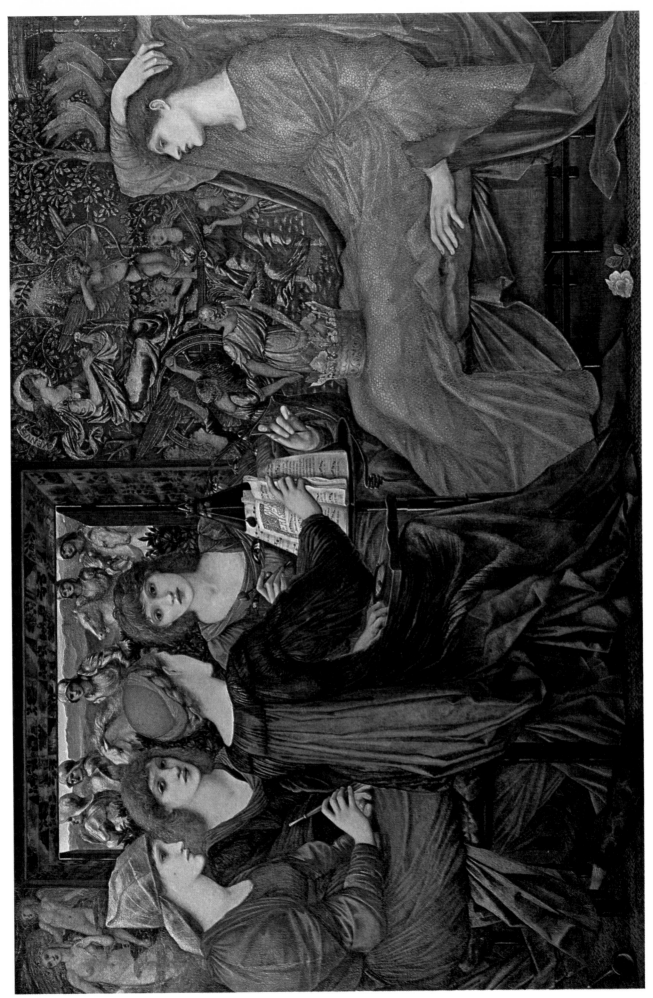

3

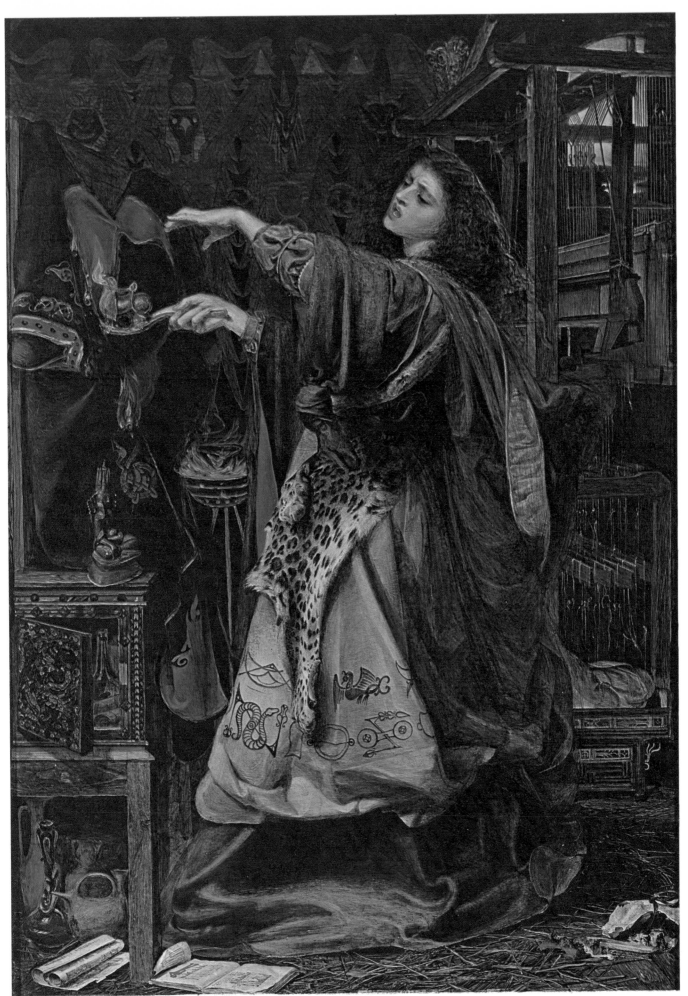

4

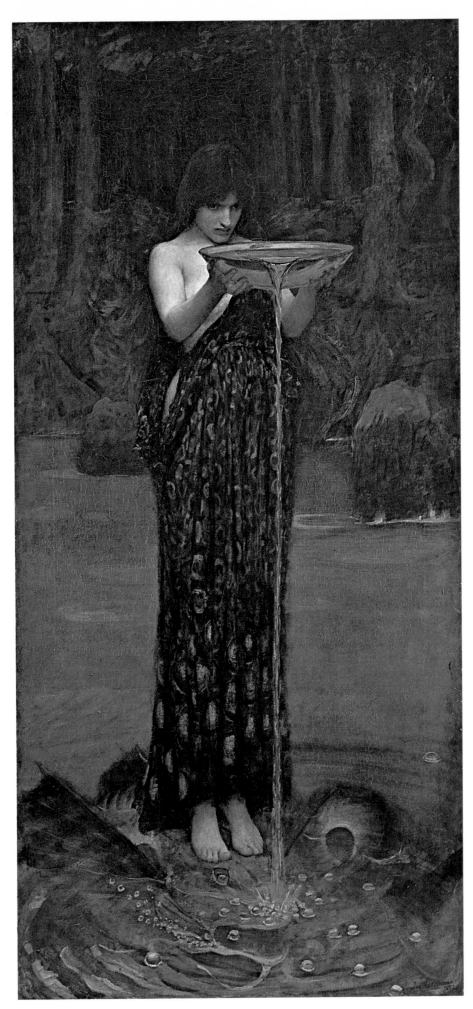

5

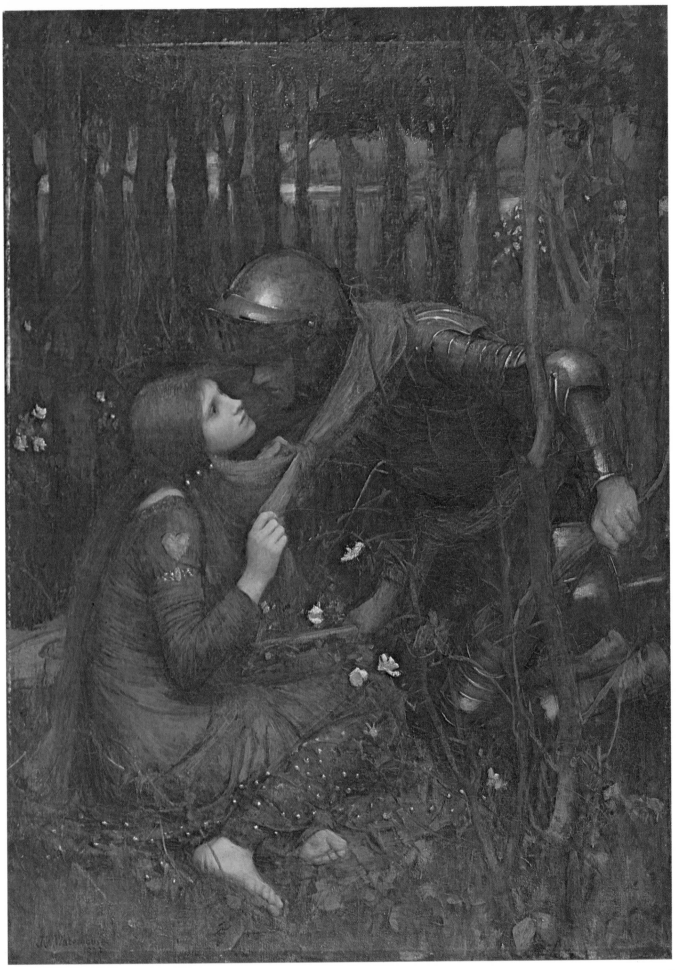

6

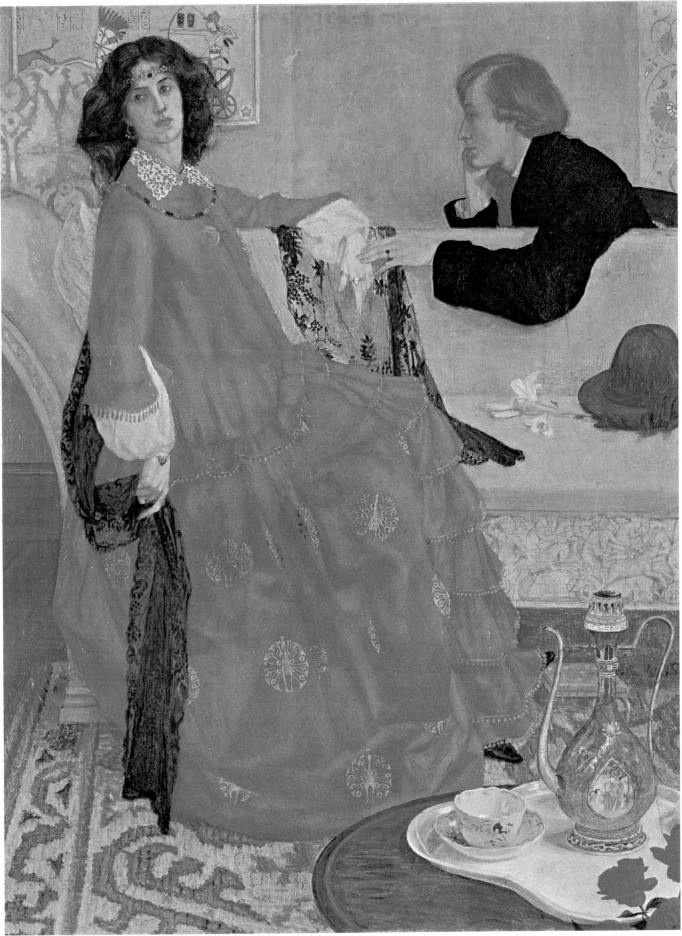

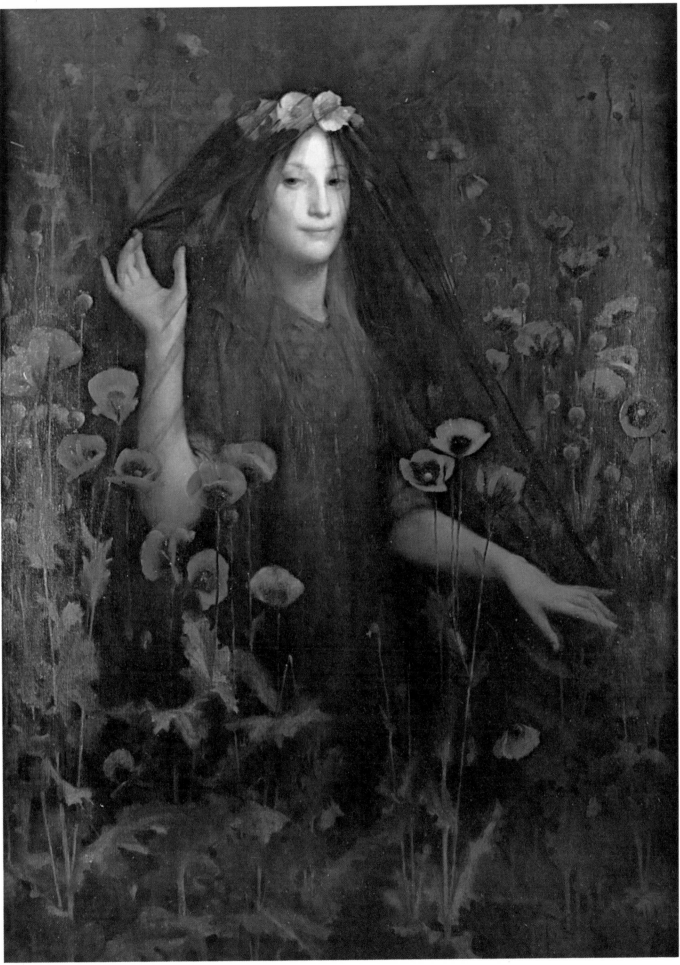

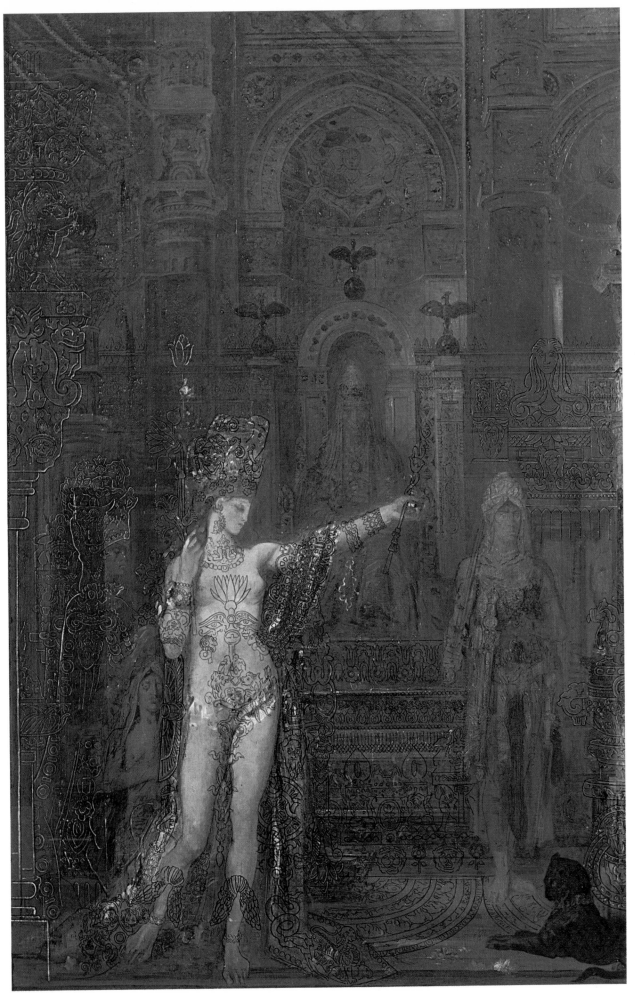

9

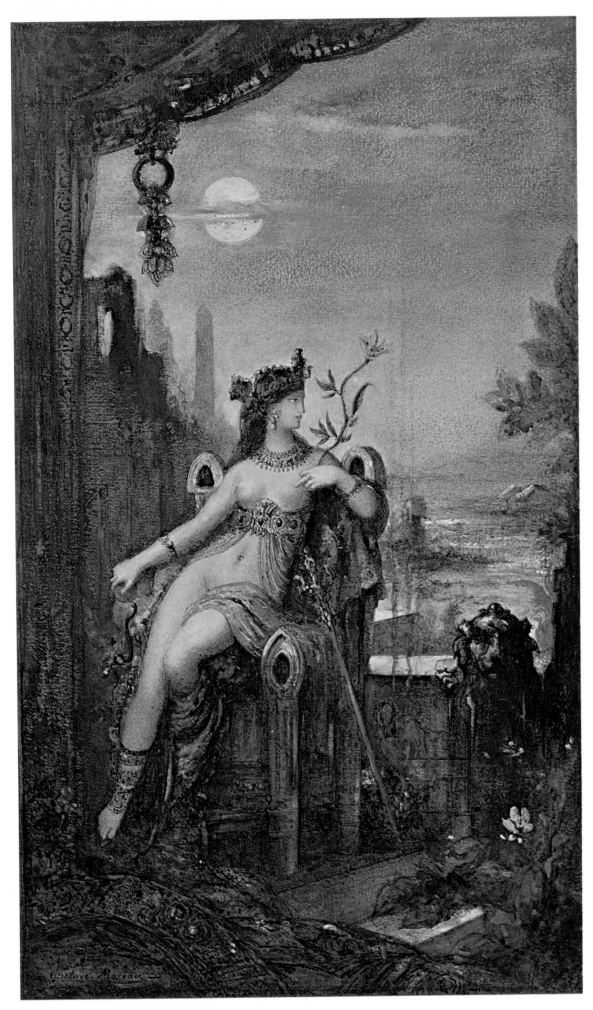

10

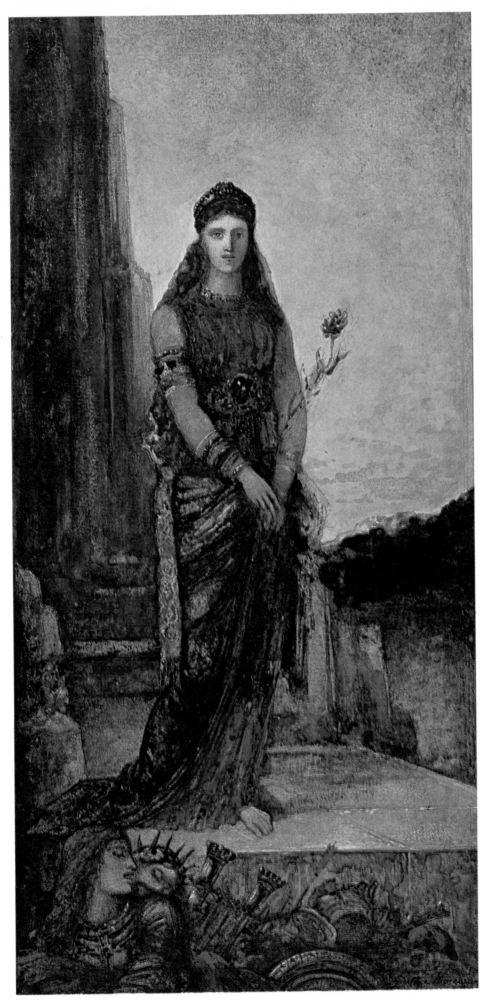

11

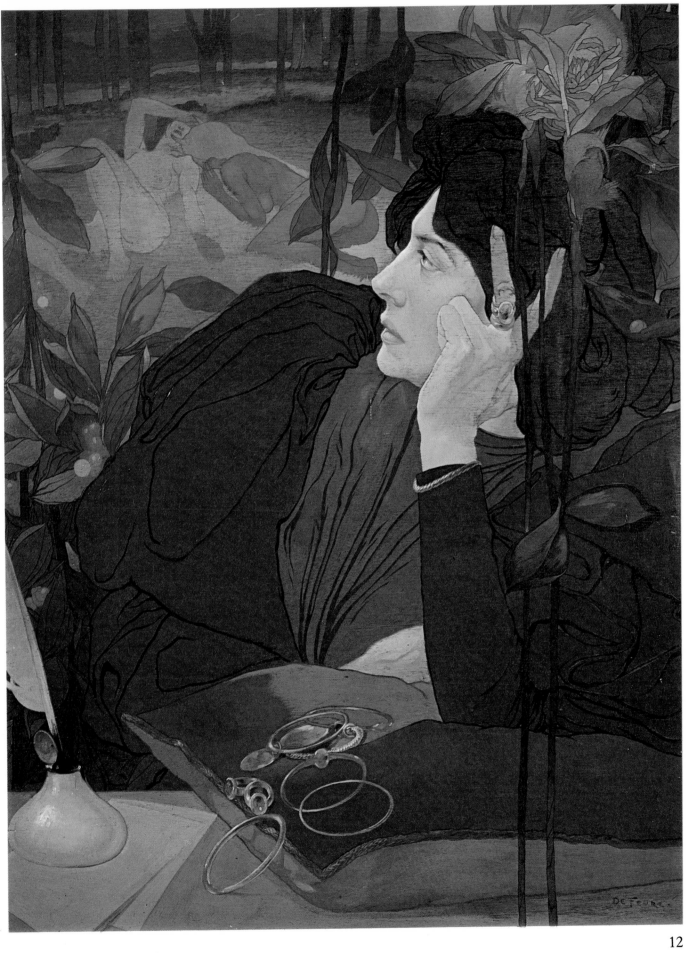

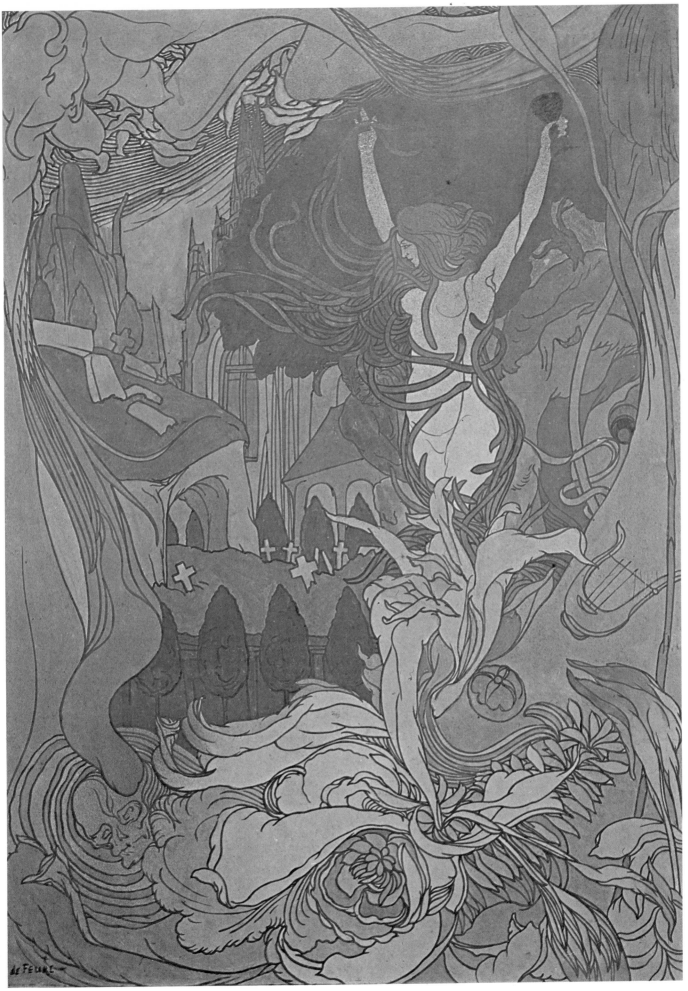

13

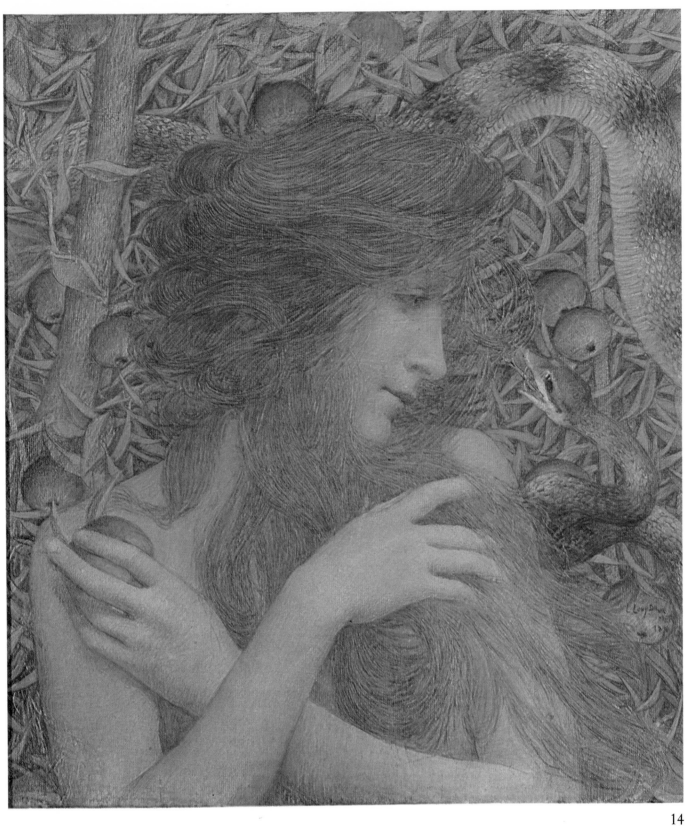

14

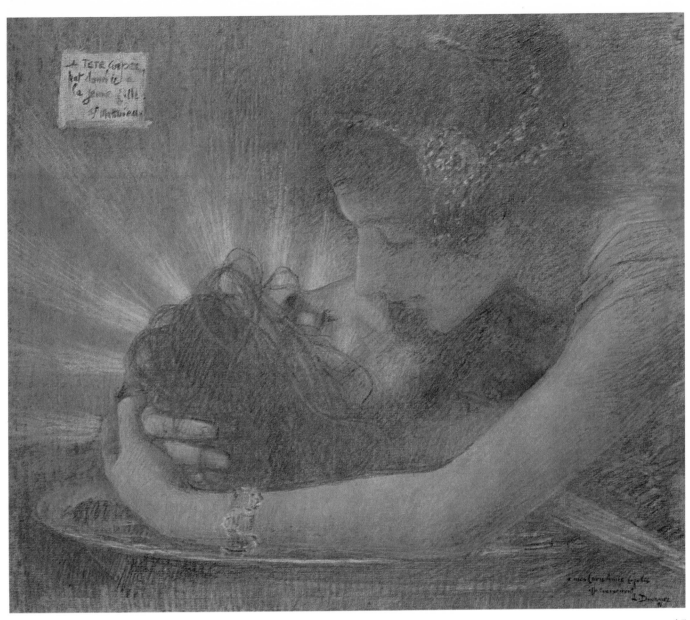

15

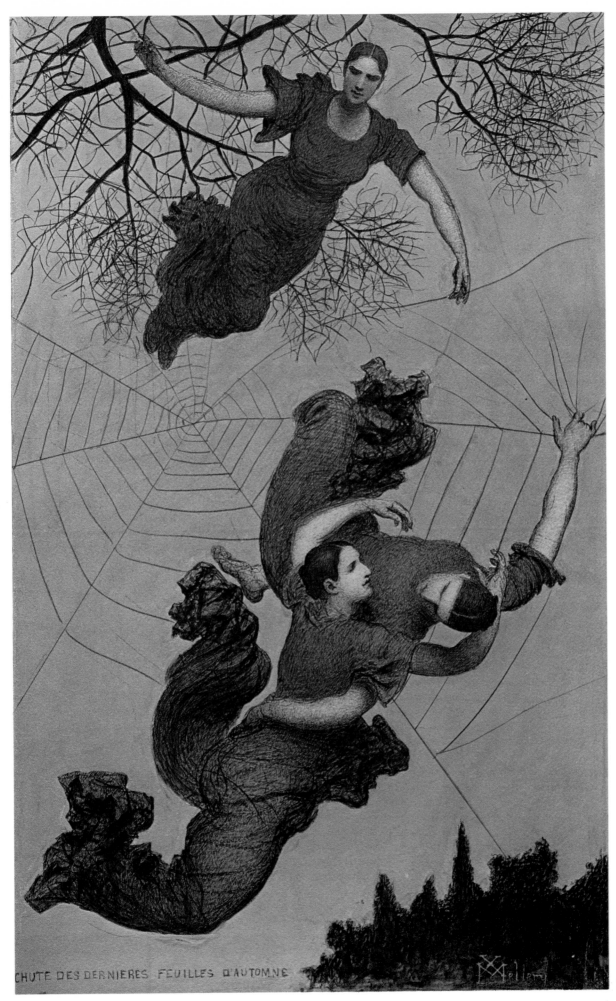

CHUTE DES DERNIERES FEUILLES D'AUTOMNE

16

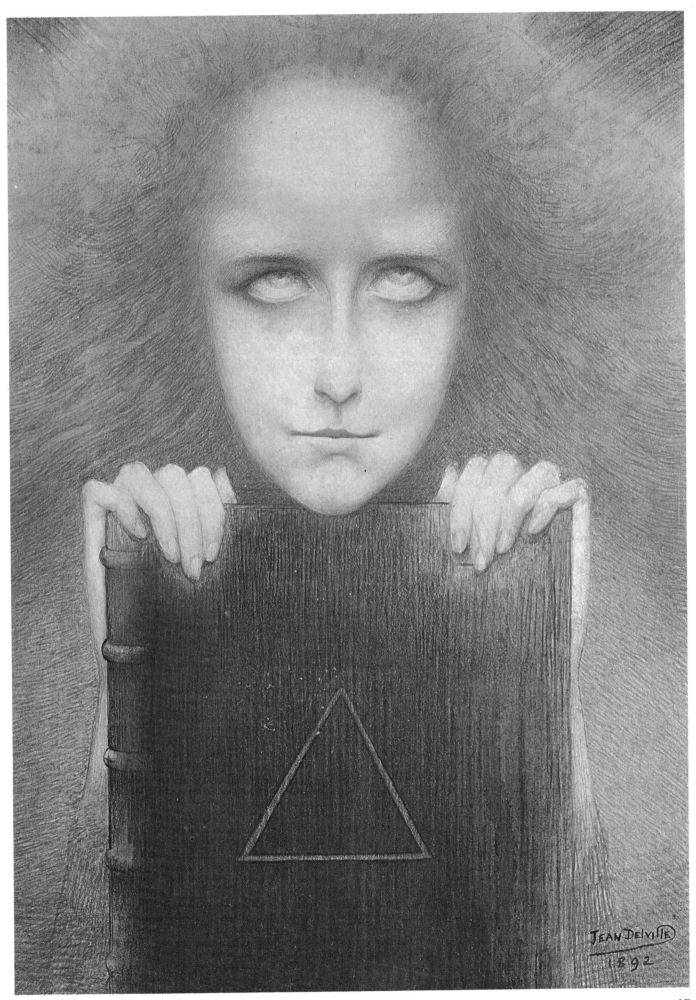

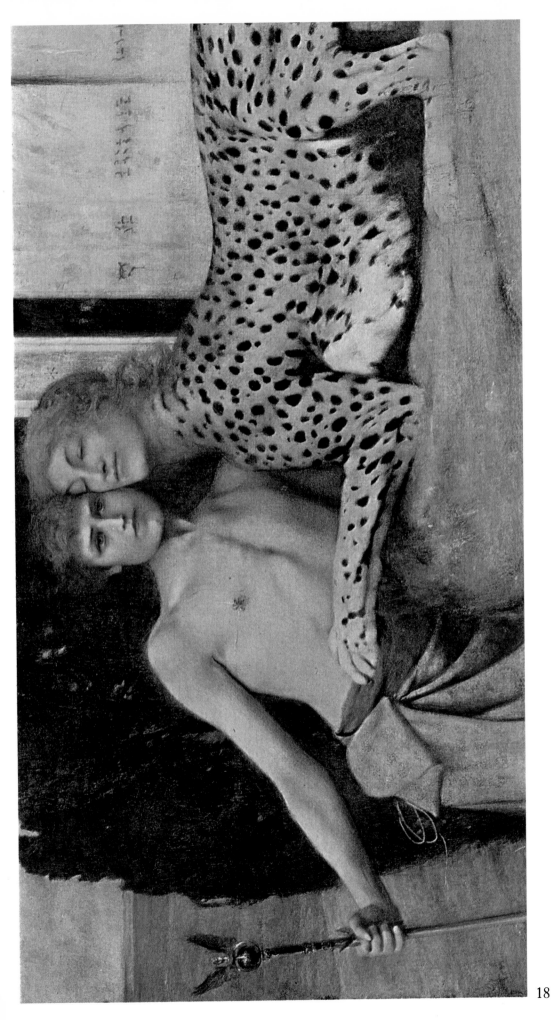

18

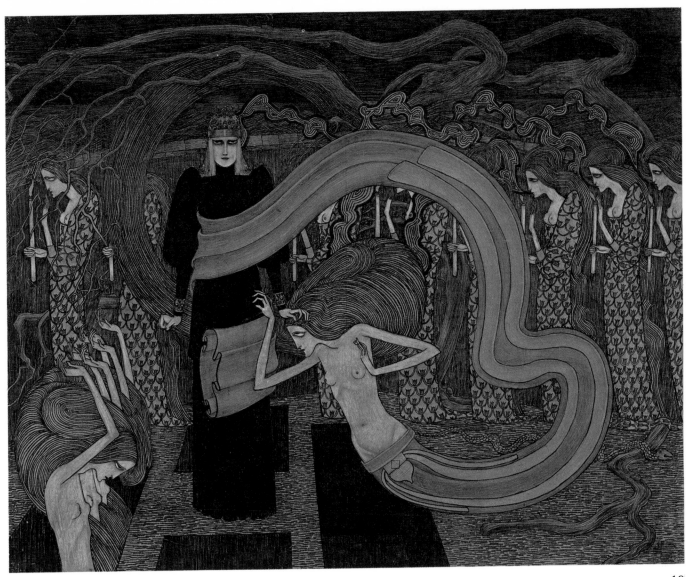

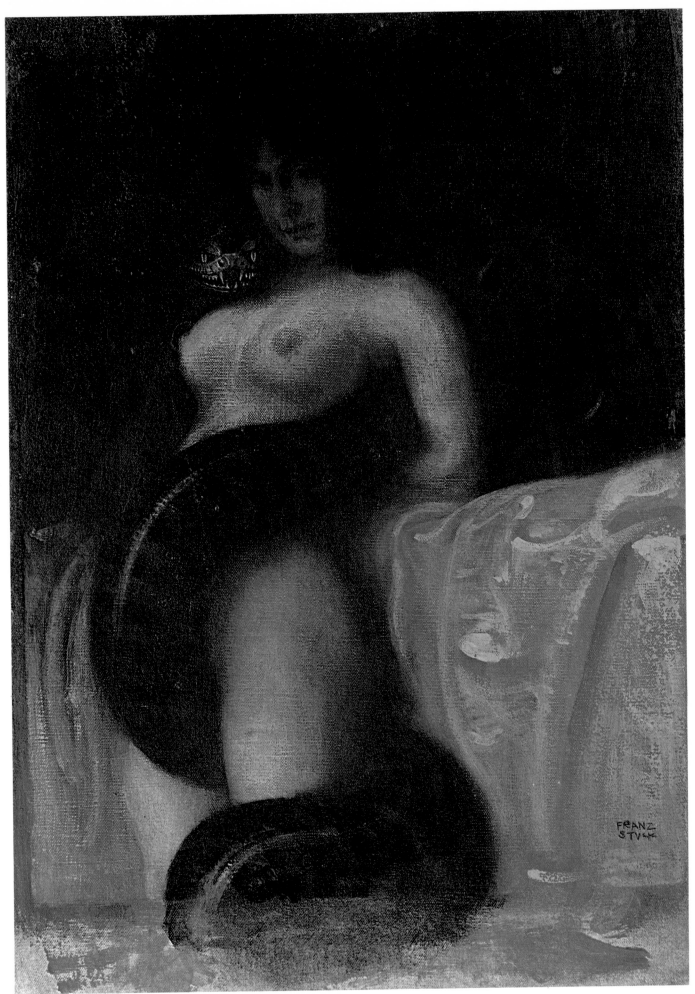

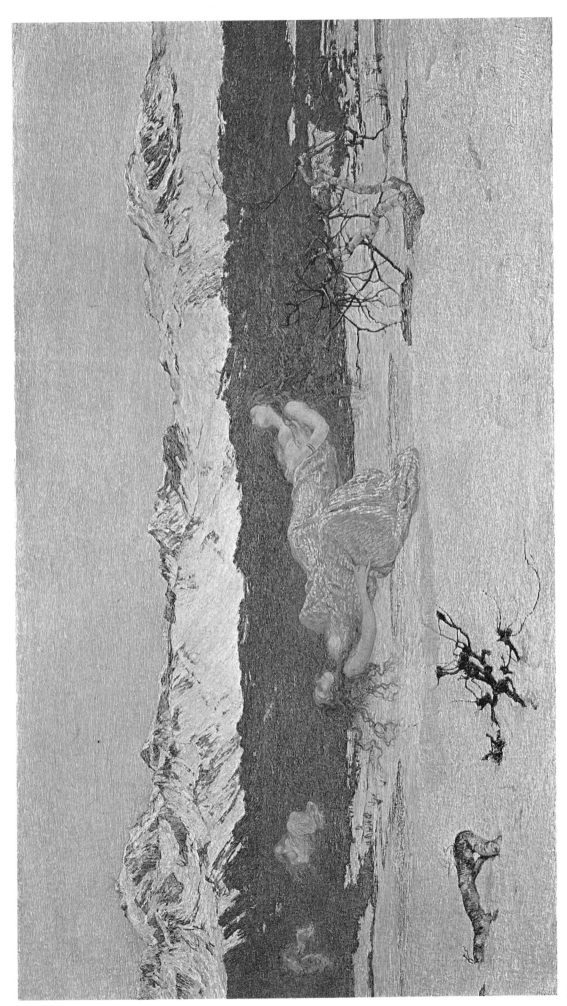

21

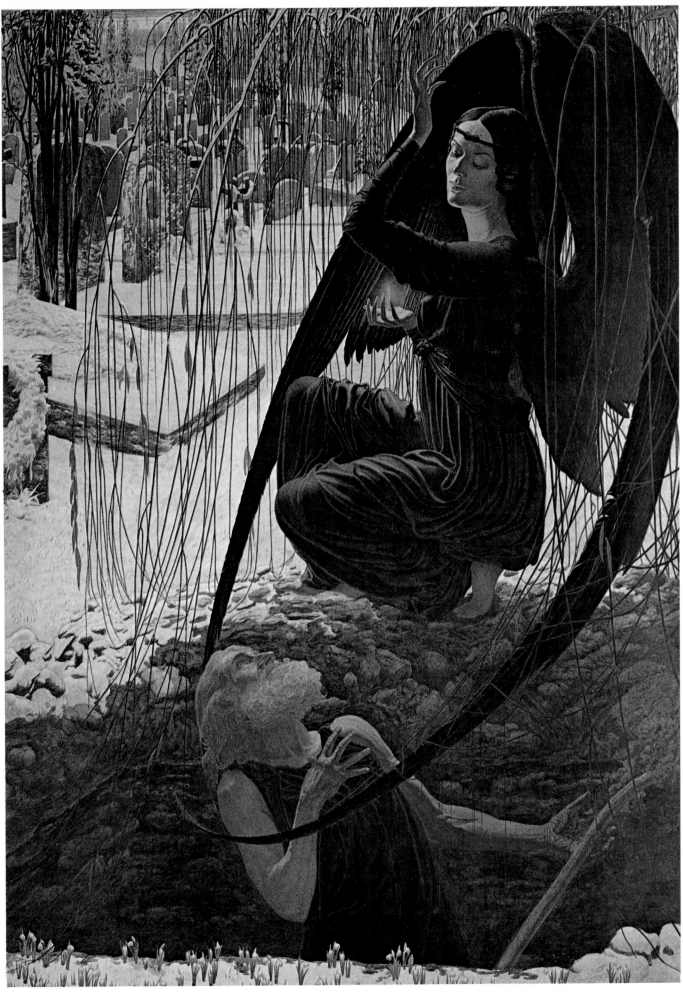

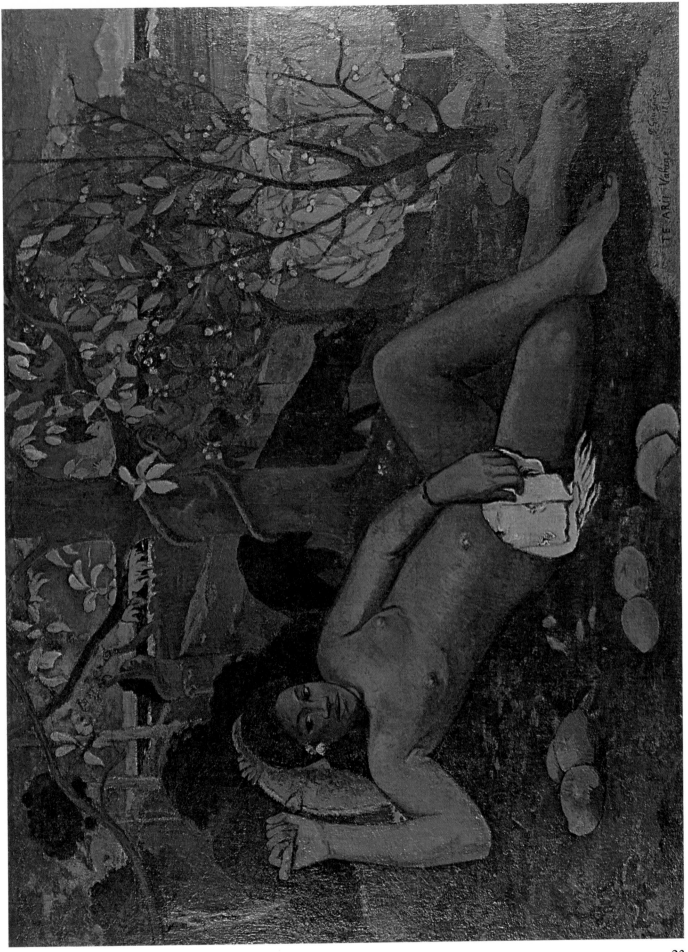

23

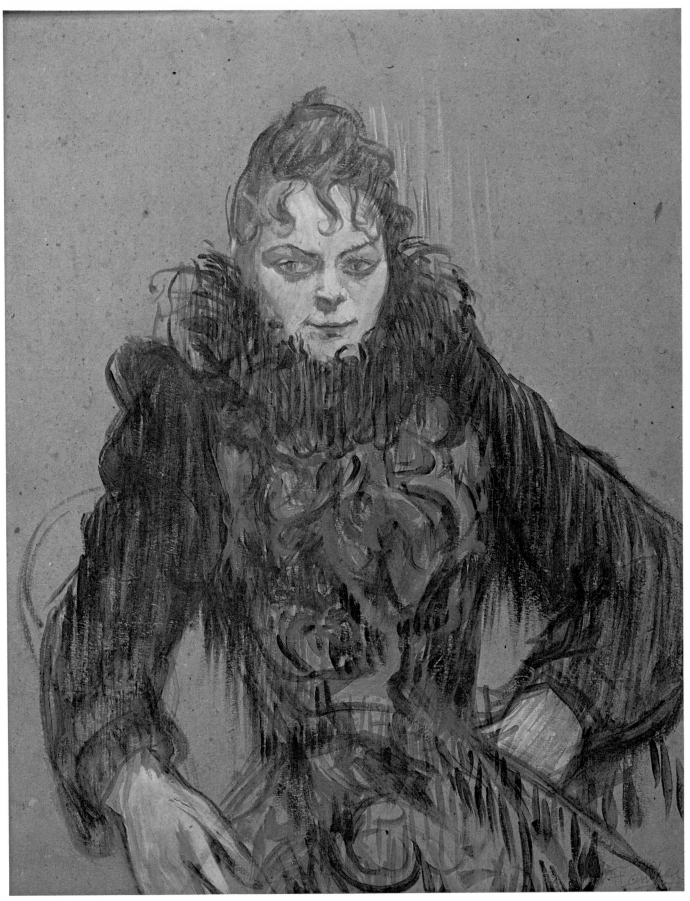

24

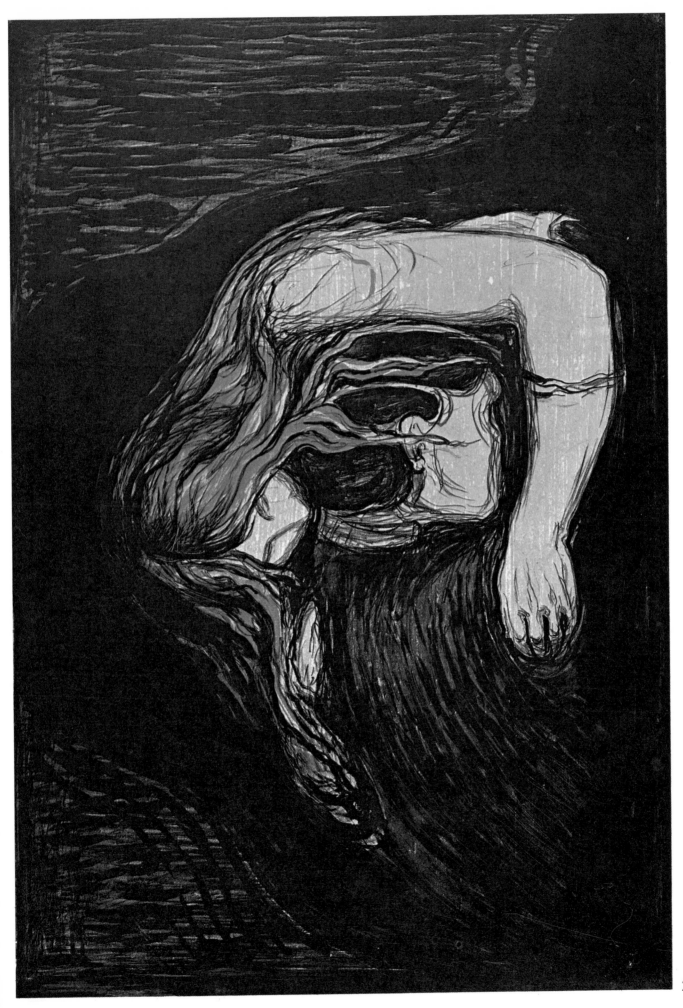

25

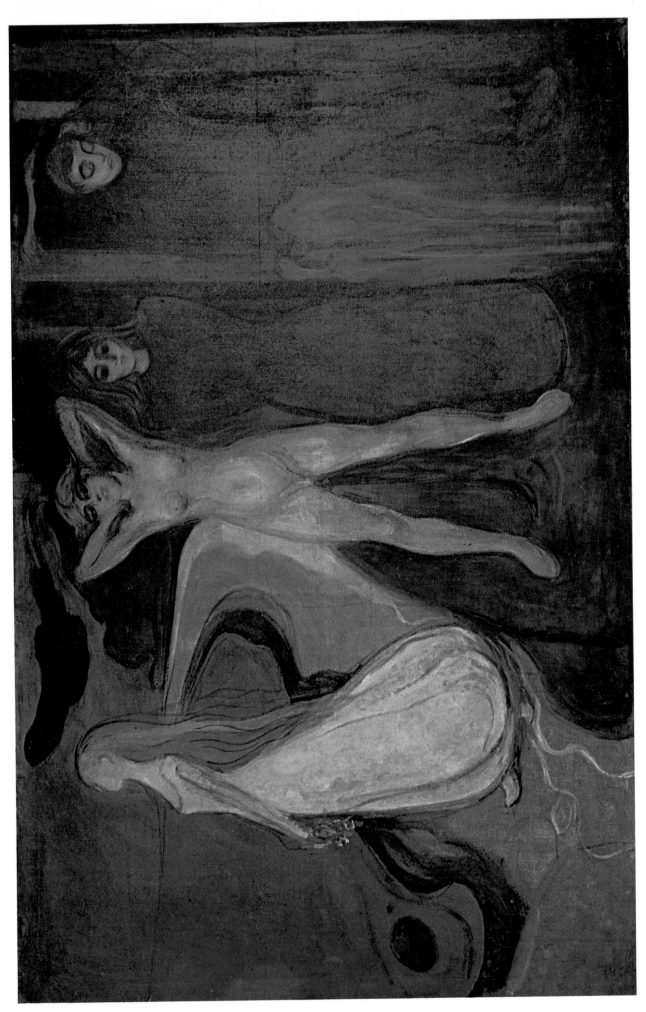

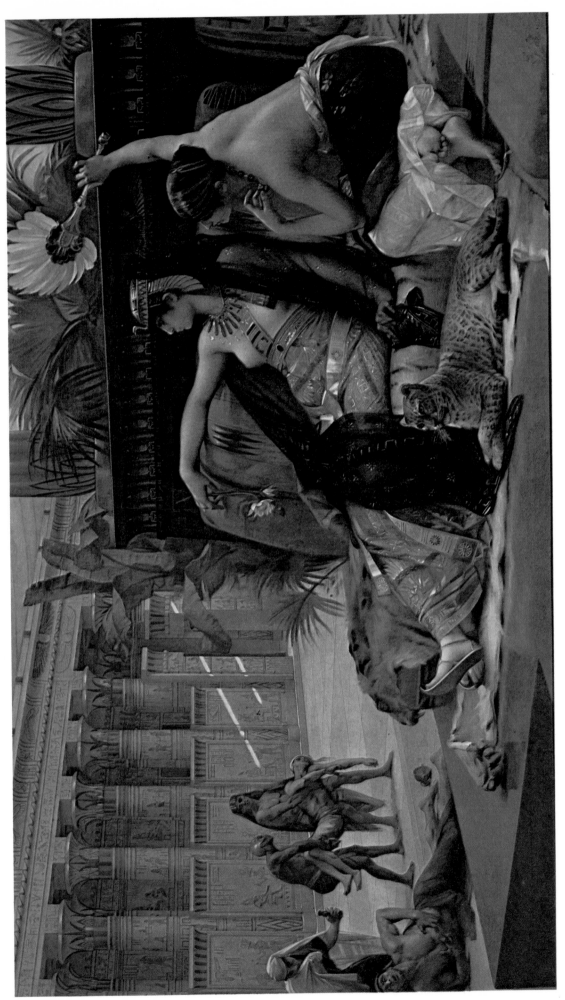

27

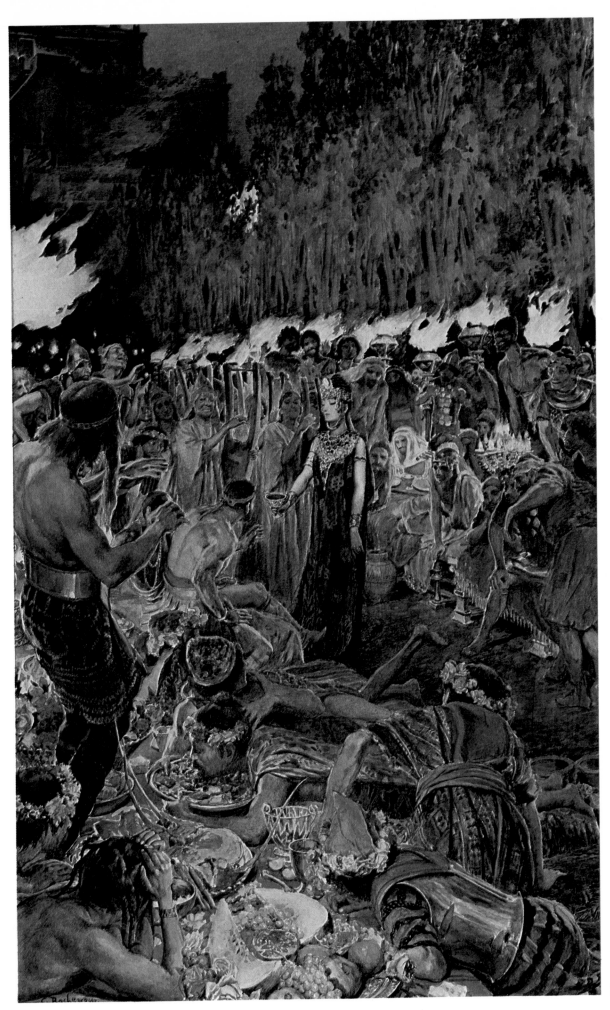

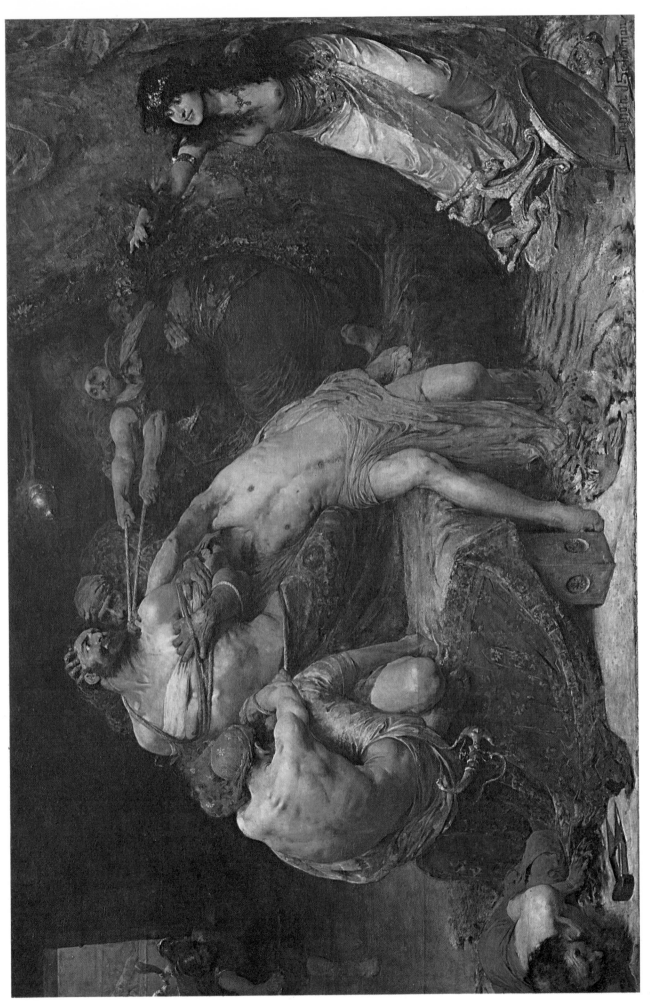

29

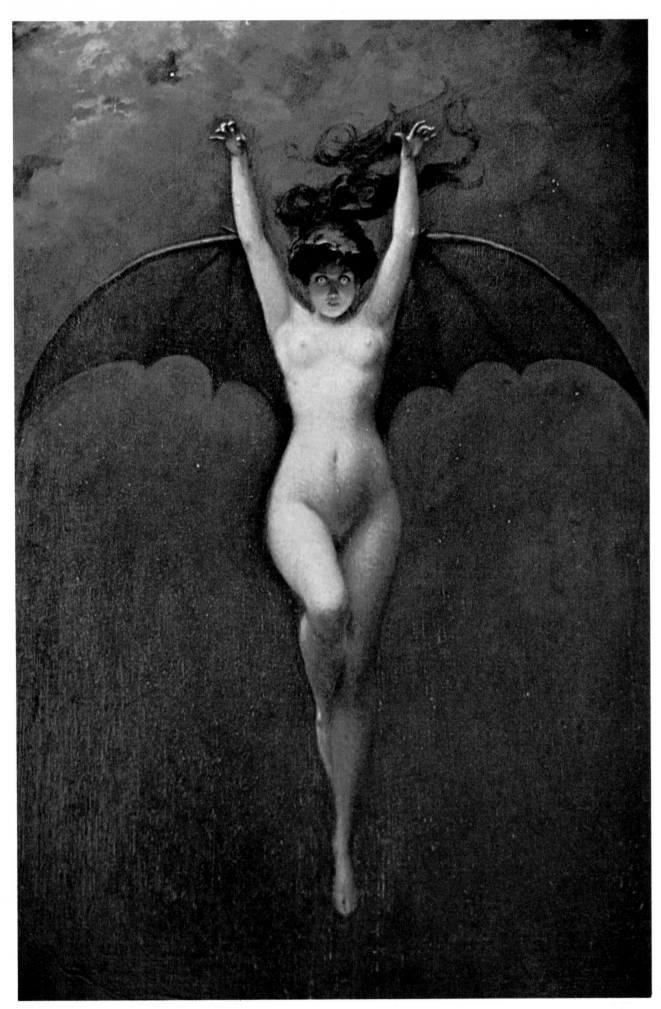

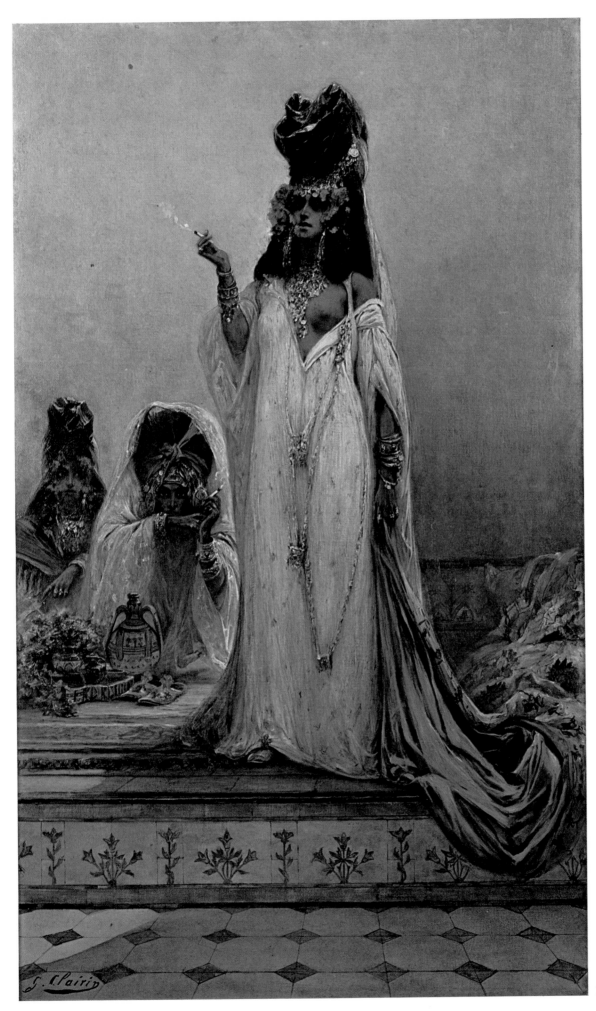

31

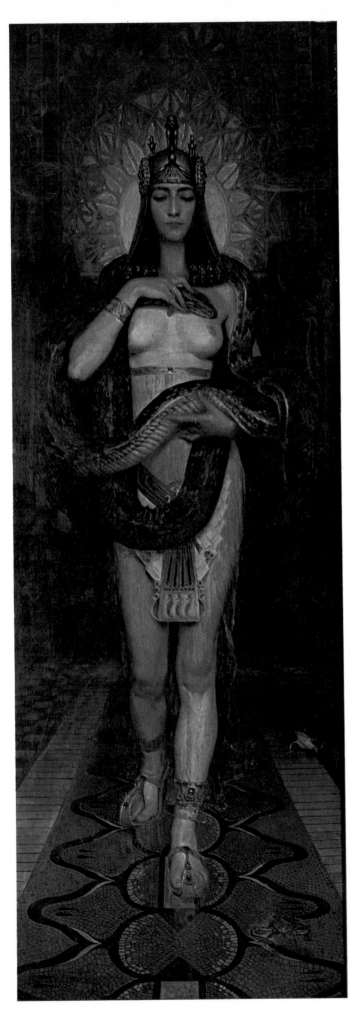

32

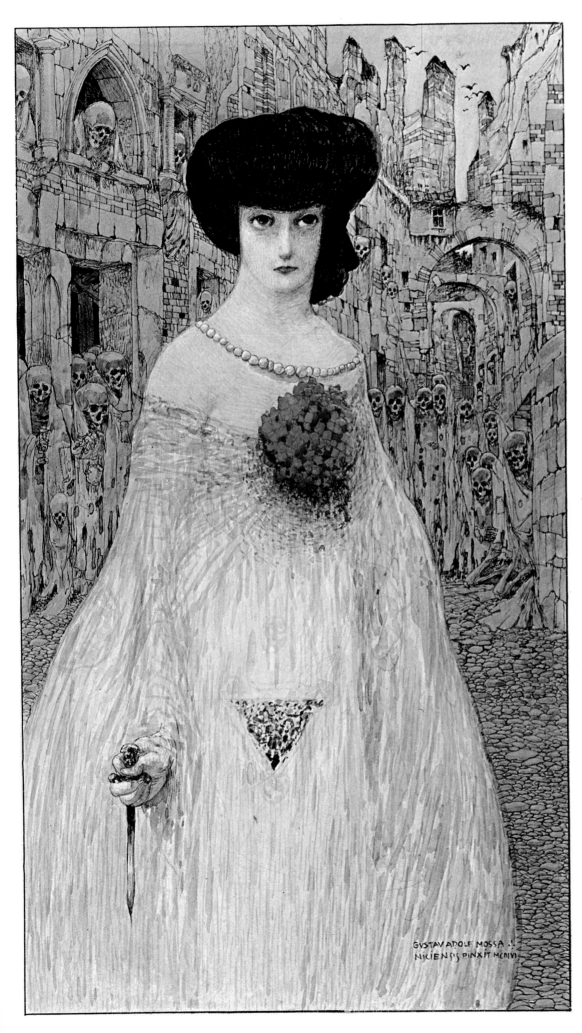

33

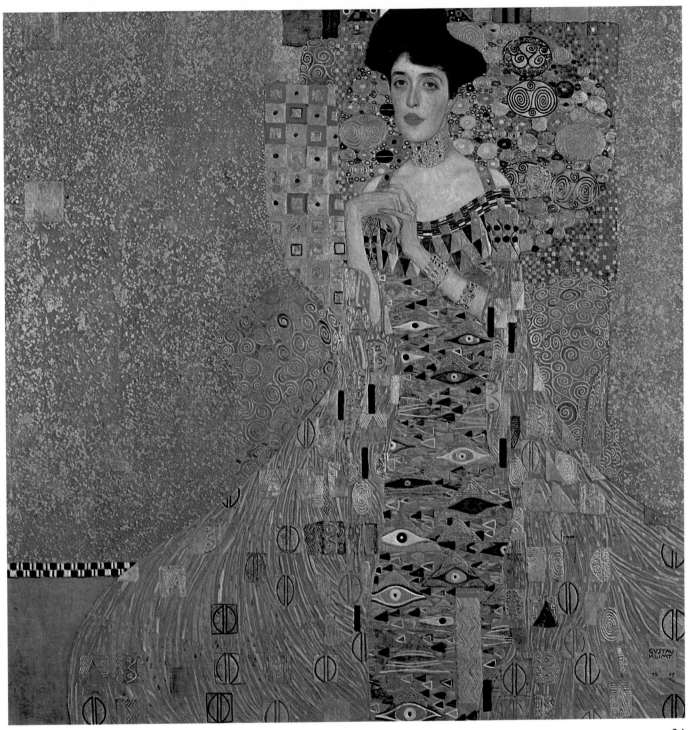

34

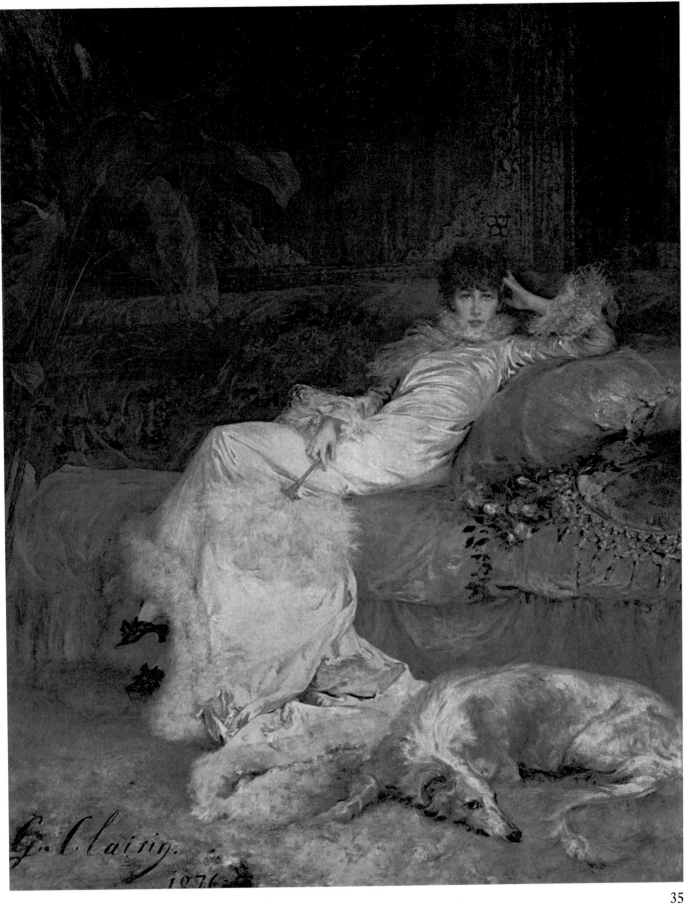

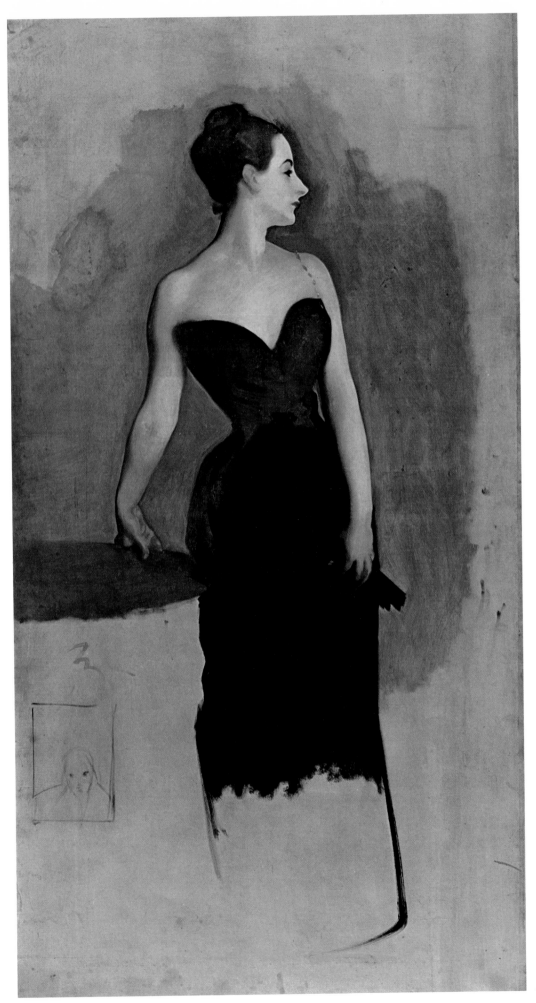

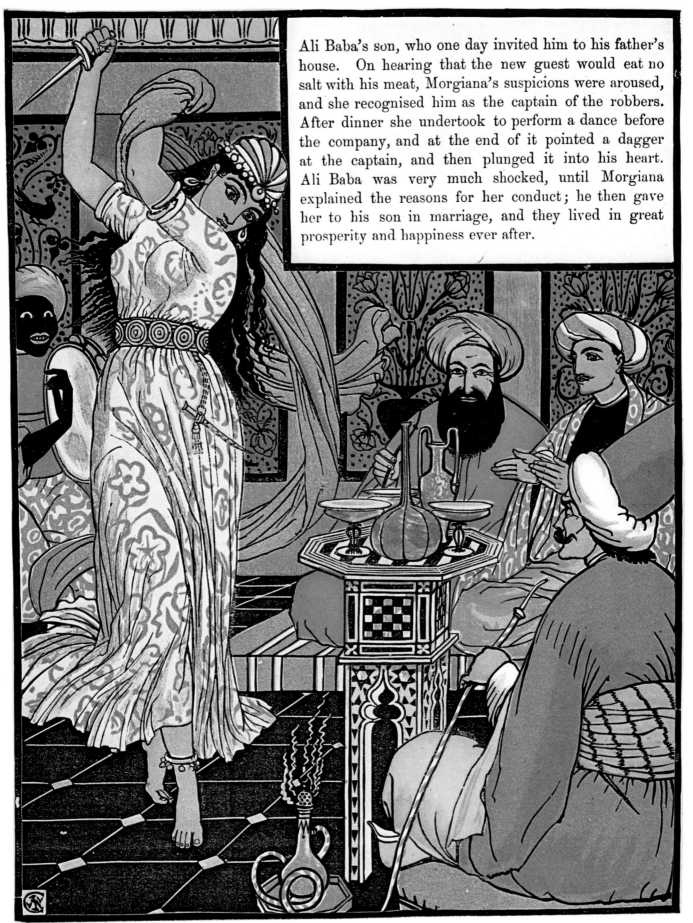

Ali Baba's son, who one day invited him to his father's house. On hearing that the new guest would eat no salt with his meat, Morgiana's suspicions were aroused, and she recognised him as the captain of the robbers. After dinner she undertook to perform a dance before the company, and at the end of it pointed a dagger at the captain, and then plunged it into his heart. Ali Baba was very much shocked, until Morgiana explained the reasons for her conduct; he then gave her to his son in marriage, and they lived in great prosperity and happiness ever after.

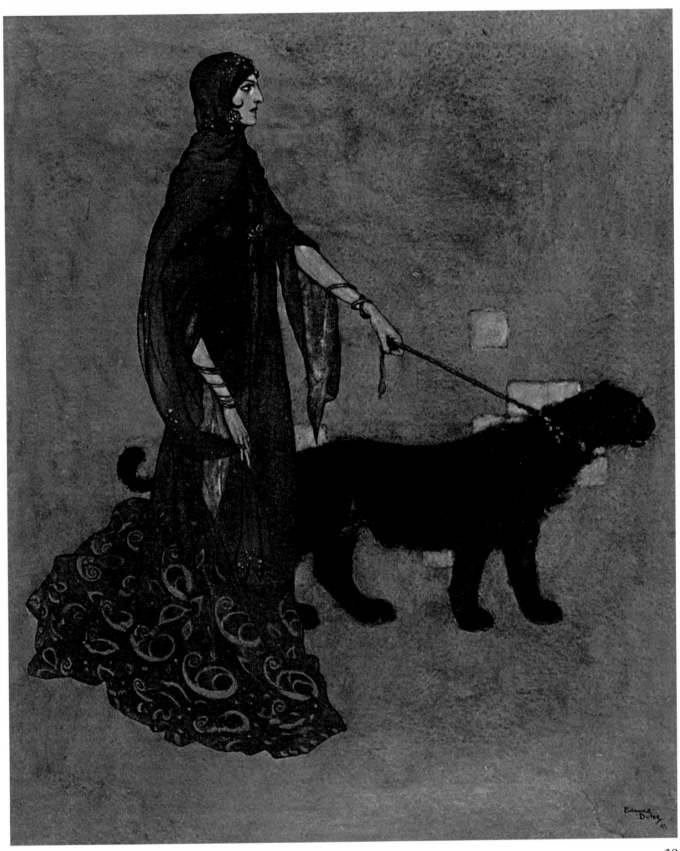

38

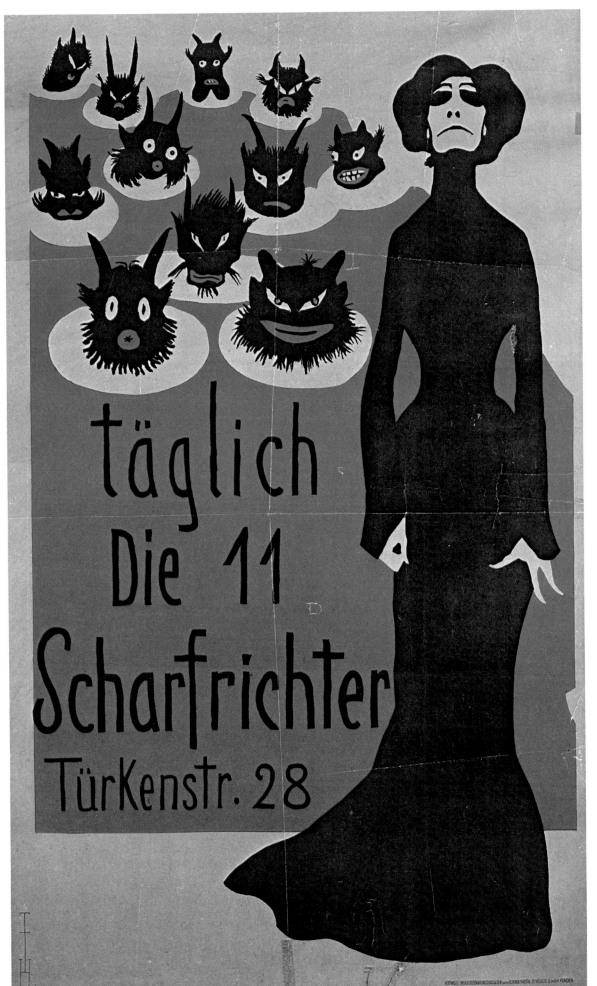

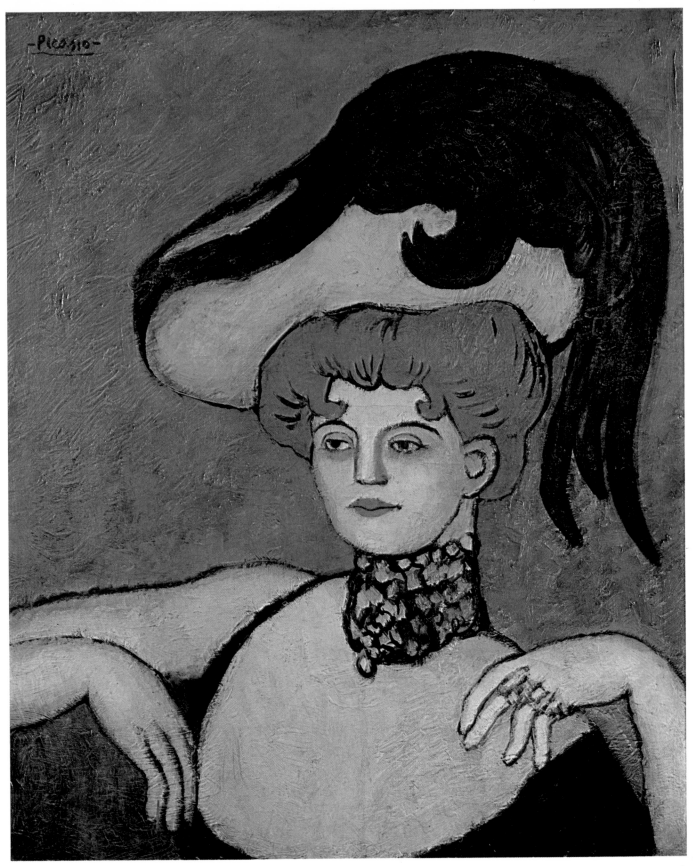

Notes to the colour plates

Dante Gabriel Rossetti (1828-82)
1 *Astarte Syriaca* 1877, oils.
The sultry features of Jane Morris are immediately recognisable in Rossetti's awesome depiction of Astarte, the cruel Babylonian fertility goddess. In an authoritative biography of Rossetti published in 1904, A. E. Benson wrote of this picture, 'Here indeed the two attendants with their torches and upward glance seem to testify to some dark, unholy power, the cruelty that is akin to lust. The strange sights that she has seen in grave and shrine seem to have fed her beauty with lurid and terrible royalty, where she reigns in a dark serenity which nothing can appal.'

Edward Burne-Jones (1833-98)
2 *Sidonia von Bork* 1860, gouache.
Sidonia von Bork is the heroine of the German novel, *Sidonia the Sorceress*, by Wilhelm Meinhold. Her beauty fascinates all who see her, and she uses magical powers to destroy all those who impede her evil plans. The novel was greatly admired by Rossetti, and the choice of this subject as well as Sidonia's physical type and the compressed space of the composition show Burne-Jones' debt to Rossetti at this early date in his career. The elaborate pattern of Sidonia's dress, which effectively suggests a spider's web of sinister intrigue, was borrowed from a portrait by Giulio Romano.

3 *Laus Veneris* 1873-5, oils.
Burne-Jones' painting was inspired by Swinburne's poem 'Laus Veneris' which was dedicated to Burne-Jones and which was published in *Poems and Ballads* in 1866. Swinburne's treatment of the medieval legend of the knight Tannhäuser, who fell into the clutches of Dame Venus, may itself have been inspired by Wagner's opera *Tannhäuser* which received its controversial Paris première in 1860. In Burne-Jones' painting, narrative is subordinated to a general feeling of malaise. Henry James commented that Venus had 'the aspect of a person who has had what the French call an intimate acquaintance with life' and that her companions were 'pale, sickly and wan in the manner of all Mr Burne-Jones' young people'.

Frederick Sandys (1829-1904)
4 *Morgan Le Fay* 1864, oils.
Frederick Sandys, who was heavily influenced by Rossetti, was a largely self-taught artist on the periphery of the Pre-Raphaelite circle. For this painting Sandys has drawn upon Malory's *Morte Darthur*, one of the favourite source books of Pre-Raphaelite subject matter. Morgan Le Fay was one of the sisters of King Arthur. She possessed magical powers which she used for evil purposes.

John William Waterhouse (1849-1917)
5 *Circe Poisoning the Sea* 1892, oils.
Waterhouse was one of the most accomplished of the numerous minor followers of the Pre-Raphaelites. He successfully combined Pre-Raphaelite subject matter and mood with a looser and more painterly technique and developed a distinctive type of youthful feminine beauty based on that of Burne-Jones. According to classical legend, Circe was a sorceress who had the power to transform men into animals. She poisoned the sea in order to be rid of the nymph Scylla who was a rival for the love of Glaucus.

6 *La Belle Dame Sans Merci* 1893, oils.

> *I saw pale kings and princes too,*
> *Pale warriors, death-pale were they all;*
> *They cried – 'La Belle Dame sans merci*
> *Thee hath in thrall!'*
> John Keats

Although Keats described 'La Belle Dame' as having long hair, the image of the man entrapped in a woman's hair was propagated by Rossetti rather than by Keats. This image was also used by Swinburne, Munch and by Maeterlinck in a famous and frequently illustrated scene in his play *Pelléas and Mélisande*.

Maxwell Armfield (1882-1972)
7 *Faustine*, oils.
'Faustine' is the title of a poem by Algernon Swinburne. Among those who were excited by the poem's publication in 1862 was John Ruskin, the most influential critic in Victorian England. The high-minded Ruskin wrote to Swinburne that 'Faustine' had made him 'all hot like pies with the devil's fingers in them'. Maxwell Armfield's painting is not a literal illustration of Swinburne's poem, which describes a Roman Empress who takes a sadistic delight in gladiatorial games. Instead Armfield shows Swinburne himself gazing at a woman who represents the poet's ideal of sultry and malevolent beauty.

Thomas C. Gotch (1854-1931)
8 *Death the bride* 1895, oils.
Thomas Gotch began his career as a member of the Newlyn School of painters who are best known for their realistic and anecdotal pictures of fisherfolk. In the early 1890s he was much affected by a visit to Florence and turned to painting symbolic and allegorical works which show the influence of Pre-Raphaelitism and French Symbolism, as well as of the Quattrocento masters. The equation of seduction and death in this painting and the depiction of death in female form are typical of the period.

Gustave Moreau (1826-98)
9 *Salome dancing before Herod* (*The Tattooed Salome*) 1876, oils.
Moreau was the first of many late nineteenth-century painters to become fascinated with the character of Salome. This painting is one of the best known of his numerous versions of the subject. Moreau's tendency to concentrate obsessively on decorative accessories, leaving his heroine insubstantial and hieratic, recalls Flaubert's treatment of the heroine of his novel *Salammbô*. There is a striking parallel between the accumulation of precious and glittering detail in this painting and the detailed verbal descriptions of Flaubert.

10 *Cleopatra*, watercolour.
The lines of Cleopatra's body form a graceful and decorative arabesque. This exquisite watercolour is as far removed as possible from the academic historicism of Cabanel's *Cleopatra* or from the gross substantiality of the nudes of the realist school.

Once again Moreau's picture might serve as an illustration for Flaubert's *Salammbô* who worshipped the moon from the roof of her father's palace.

11 *Helen on the ramparts of Troy*, watercolour.
J.-K. Huysmans described Moreau's Helen: 'She stands out against a sinister horizon, drenched in blood, and clad in a dress encrusted with gems like a shrine. Her eyes are wide-open in a cataleptic stare. At her feet lie piles of corpses. She is like an evil goddess who poisons all that approach her.' Whether he painted Salome, Cleopatra, Helen on the ramparts of Troy above the heaped bodies of her victims, or the Virgin seated on a throne 'drenched with the blood of martyrs', Moreau essentially depicted the same blood-thirsty, destructive woman.

Georges de Feure (1869-1928)
12 *The voice of evil* 1895, oils.
Although de Feure was of Dutch and Belgian parentage, his work as an artist and designer typifies the exquisite and precious elegance of Parisian Art Nouveau. He worked as a designer for the entrepreneur Samuel Bing, whose shop, 'L'Art Nouveau', gave its name to the style. De Feure was strongly influenced by the poet Charles Baudelaire. The favourite theme of his highly decorative paintings in oils and watercolours is the malignancy and evil fascination of women. The title of this work and the undertones of lesbianism, with the two writhing female figures apparently in the mind's eye of the melancholic woman in the foreground, are redolent of Baudelaire.

13 *The door of dreams* c. 1897-8, watercolour.
De Feure produced this watercolour design in connection with his illustrations for a collection of short stories by the Symbolist writer Marcel Schwob, published in 1899. The adulation of woman as an evil idol and the blasphemous inversion of Christian imagery are characteristic of de Feure's work.

Lucien Lévy-Dhurmer (1865-1953)
14 *Eve* 1896, pastel and gouache.
Lévy-Dhurmer has endowed the first femme fatale with the gentle Leonardesque beauty tinged with Pre-Raphaelitism which characterised his work in the 1890s. The snake has a decorative beauty very different from the slimy serpent of Stuck's *Sensuality*. According to the contemporary critic Léon Thévenin, the woman in this picture 'exiled from Eden, is a symbol of the pagan world, of the rule of nature and of the senses'.

15 *Salome* 1896, pastel.
Lévy-Dhurmer executed this gruesome pastel in the same year that Oscar Wilde's play *Salome* received its Parisian première, though the phosphorescent glow around the severed head accords more with the account of the death of the Baptist in *Les moralités légendaires* by the French poet Jules Laforgue, published nine years previously. The particular horror of this version of the subject lies in the intimacy and tenderness of Lévy-Dhurmer's depiction. The illusionistically drawn slip of paper in the top left hand corner of the picture bears the inscription: 'The severed head was given to the young girl – St Matthew'.

Xavier Mellery (1845-1921)
16 *Autumn*, watercolour, pencil and chalk.
Mellery was an important precursor of the Belgian Symbolists and the teacher of Khnopff. Mellery's women are suspended in a web, like human spiders. The spider who devours her mate was a metaphor frequently used by writers for the supposedly predatory nature of women.

Jean Delville (1867-1951)
17 *Portrait of Mrs Stuart Merrill* 1892, coloured chalk.
The Belgian artist Jean Delville was closely involved with the Symbolist Salon de la Rose+Croix, founded by the eccentric Joséphin Péladin in 1892, and he enjoyed his greatest successes there during its five year existence. Péladin dabbled in the occult and claimed magical powers. The eerie quality of this portrait, which can hardly have been a physical likeness, indicates that Delville shared Péladin's occult interests.

Fernand Khnopff (1858-1921)
18 *The Caress* 1896, oils (detail).
This elegant and enigmatic painting is the most famous of Khnopff's strange and compelling depictions of female hybrids. The features of his sister, who haunted so much of his work, can be discerned in the head of the sphinx. The heads of the young man and the sphinx have a curiously similar androgynous quality which heightens the mood of decadent ambiguity.

Jan Toorop (1858-1928)
19 *Fatality* 1893, drawing.
This complex and mysterious picture by the Dutch-Javanese artist Jan Toorop is a symbolic depiction of the fate which hinders the search for a higher spiritual world. As Toorop explained, the woman in black is 'ensnared by the sinuous power of fatality which she tries to repel with her hand, while to the left three other symbols of fatality emerge from their tombs to trap and destroy their prey'.

Franz von Stuck (1863-1928)
20 *Sensuality* 1891, oils.
Franz von Stuck, the wealthy 'painter-prince' of Munich, achieved the greatest success of his career with the painting *Sin*, which was hailed as a work of genius at the 1893 exhibition of the Munich Secession. Rows of seats had to be placed in front of the painting for the crowds of fascinated viewers. *Sin* was a variant of the yet more suggestive *Sensuality* which Stuck had painted four years previously. So great was the demand for these pictures that Stuck painted at least eighteen versions of the subject of a woman entwined with a snake under the titles of *Sin*, *Sensuality*, and *Vice*.

Giovanni Segantini (1858-99)
21 *The punishment of luxury* 1891.
The punishment of luxury is one of three pictures by Segantini inspired by a passage in the Indian poem 'Pangiavahli', which describes the punishment meted out to women who have rejected the biological role of motherhood. 'Thus the bad mother in the livid valley, in the eternal cold where no branch turns green and no flower blossoms, turns ceaselessly.'

Carlos Schwabe (1866-1926)
22 *The death of the grave-digger* 1895-1900, watercolour and gouache over pencil.
The German-born Carlos Schwabe moved to Paris in the 1890s, where he was much influenced by literary Symbolism and exhibited at the Symbolist Salon de la Rose+Croix. *The death of the grave-digger* is yet another representation of death in female, though not especially malignant female form.

Paul Gauguin (1848-1903)
23 *Te Arii Vahine* (*The Queen of Beauty*) 1896, oils.
The queen of beauty reigns in a mysterious and exotic paradise, far removed from the reality of Tahiti in Gauguin's day. Despite the setting, the mood of the painting is that of fin-de-siècle Europe and the composition derives from a long European tradition of reclining female nudes.

Henri de Toulouse-Lautrec (1864-1901)
24 *The woman with the black boa* c.1892, oils.
The chalky pallor, blackened eyes and red lips of this contemporary Parisienne of the demi-monde sketched by Lautrec, give her an appearance as sinister as the imaginary fatal women of the Symbolists. The ubiquitous boa of the 1890s carried, as its name suggests, serpentine associations.

Edvard Munch (1863-1944)
25 *Vampire* 1895, coloured lithograph and woodcut.
The woman vampire who drains the life-blood of men was an image which Munch shared with many other artists and writers of his period. The oil painting *Vampire*, belonging to the series *The Frieze of Life*, was executed in 1893 and this graphic version of the same subject two years later. Munch repeated the compositions of many of his oil paintings in woodcuts and lithographs and was frequently able to express his ideas in more powerful and concentrated form in his graphics.

26 *The Three Stages of Woman* 1894, oils.
This painting belongs to the *Frieze of Life* series. The theme of the three aspects of woman – virgin, whore and nun, is related to that of the *Dance of Life* from the same series and to Jan Toorop's *The Three Brides*, a work executed the previous year. Munch has given a more misogynist meaning to the traditional and which was used in the 1880s by Seurat and Puvis de Chavannes.

Alexandre Cabanel (1824-84)
27 *Cleopatra trying out poisons on her lovers* 1887, oils.
Alexandre Cabanel was a leading academic painter and one of the most successful artists of his time. He is now chiefly remembered as the artist whose painting *The Birth of Venus* was the most admired work at the Salon of 1863, from which Manet's *Luncheon on the grass* was rejected. Cabanel's more impressive *Cleopatra*, exhibited nearly a quarter of a century later, presents an interesting comparison to Manet's *Olympia*, showing how the type of the femme fatale cut across stylistic divisions, and was incorporated even into the most reactionary history painting.

Georges-Antoine Rochegrosse (1859-1938)
28 *Salammbô*, watercolour.
Rochegrosse has faithfully followed Flaubert's minutely detailed description of Salammbô's first appearance, followed by a procession of eunuchs among the feasting mercenaries. Her distant and virginal beauty excites the sex-starved soldiers. 'It was the moon that had made her so pale, and something god-like enveloped her like a subtle essence. The pupils of her eyes seemed to gaze into distant terrestial spaces.' Salammbô offers a cup of wine to the soldier Mâtho, arousing jealousy and precipitating the first violence of this blood-drenched novel.

Solomon Solomon (1860-1921)
29 *Samson and Delilah*, oils.
Solomon Solomon, who was taught by Alexandre Cabanel, was closer in his work to the masters of the Salon than to his English contemporaries. He attempts to bring a Baroque sweep to his melodramatic rendering of the biblical story, but his Delilah belongs unmistakably to the 1890s.

Albert Pénot
30 *Bat-woman* c.1890, oils.
This painting by Albert Pénot is an amusing example of an artist ineptly trying to climb onto the two fashionable bandwagons of satanism and misogyny.

Georges Clairin (1843-1919)
31 *Harem-woman*, oils.
The captive woman was a favourite theme throughout the nineteenth century. Artists would often add spice to their subjects by providing an exotic setting such as a slave market or harem. In this picture by Clairin, the theme is piquantly inverted. This particular female slave is an unlikely candidate for victimisation. She seems well able to look after her own interests and might be dangerous to any man inclined to treat her as a plaything.

Charles Allen Winter (b. 1869)
32 *Fantaisie Egyptienne* 1898, oils.
The Egyptian decor and the snake transform this painting of a healthy and otherwise innocuous young woman into a sinister allegory with associations of Cleopatra. Swinburne's lyrical effusion on the death of Cleopatra by snake-bite serves as a fitting commentary on this picture: 'a meeting of serpents which recognise and embrace, an encounter between the woman and the worm of Nile, almost as though this match for death were a monstrous love-match or such a mystic marriage as that painted in the loveliest passage of *Salammbô*, . . . For what indeed is lovelier or more luxuriously loving than a strong and graceful snake of the nobler kind?'

Gustav-Adolf Mossa (1883-1971)
33 *The woman with the skeletons* (*Lady Macbeth*) 1906, watercolour.
Mossa, who was the director of the Musée des Beaux-Arts in Nice, belonged to the same generation as the Impressionists. When he was nearing 60 he adopted Symbolist ideas and the theme of the femme fatale at a time when they were already becoming passé. He continued to make use of this kind of morbid fin-de-siècle imagery until well into the second decade of the twentieth century.

Gustav Klimt (1862-1918)
34 *Portrait of Adele Bloch-Bauer* 1907, oils.
This portrait was the first of two commissioned from Klimt by Adele Bloch-Bauer. It is one of the most extreme examples of Klimt's sumptuous, mosaic-like 'Byzantine' style. The jewelled collar and bracelets, executed in gold and silver leaf, in the same manner as the flattened ornamental background and dress fabric which enclose the more realistically painted areas of the face, shoulders and hands, create a strange effect of mutilation which Klimt often exploited in his paintings of femmes fatales.

Georges Clairin
35 *Portrait of Sarah Bernhardt*, oils.
For half a century Clairin was a devoted camp follower of Sarah Bernhardt, whom he depicted in a wide variety of roles – from Joan of Arc to Cleopatra. Most impressive of all was this portrait of Bernhardt languidly stretch out amongst the silks, satins and plush upholstery of her own boudoir, with a large dog at her feet, in place of the customary lion or panther. Clairin came to know Bernhardt's features so well that he required only her costumes, modelled by his concierge, for his numerous portraits of the actress.

John Singer Sargent (1858-1925)
36 *Portrait of Mme Gautreau* 1884, oils.
Surprisingly this portrait, which typifies the sinister elegance of the fin-de-siècle, met with a hostile reception when Sargent, at the outset of his career as a fashionable portraitist, exhibited it at the 1884 Salon. The resulting scandal was responsible for his move from Paris to London. Sargent was perhaps premature in depicting a respectable woman as a femme fatale, but it was not

long before the wealthiest women in London were clamouring to be portrayed in a similar manner. Sargent considered the portrait of Mme Gautreau to be his best painting.

Walter Crane (1845-1915)

37 Illustration to *Ali Baba and the Forty Thieves* 1873.
The versatile and prolific Walter Crane, who was one of the leading lights of the Arts and Crafts Movement, is best known as the initiator of the renaissance in illustrated children's books which took place in the late nineteenth century. The famous series of Toy Books, which began in 1865 and continued through the next two decades, was an important formative influence on the taste of several generations of children, not only in England but also on the Continent and in America. Crane remembered that early in his career he was requested not to draw his heroines 'unnecessarily covered with hair . . . long hair at that time being considered a dangerous innovation of the Pre-Raphaelite tendency'. Nevertheless the Pre-Raphaelite origins of his style are clearly discernible in this illustration to *The Arabian Nights*, despite the Middle Eastern setting and the stylistic influence of Japanese prints.

Edmund Dulac (1882-1943)

38 *The Queen of the Ebony Isles* 1907, illustration to *The Arabian Nights*.
Though of French origin, Edmund Dulac belongs with a group of English illustrators, among them Arthur Rackham and W. Heath Robinson, who combined elements of Pre-Raphaelitism, Art Nouveau and Japanese and Persian art in their work. The Queen of the Ebony Isles with her haughty manner, her snake-like armlets and her black panther, is an example of the sinister female type often found in children's books in the early years of the twentieth century.

Thomas Theodor Heine (1867-1948)

39 Poster for *The Eleven Executioners* 1901.
The Eleven Executioners was a cabaret founded in 1901 with the aim of attacking social hypocrisy and the repressive obscenity laws which had recently been passed in Germany. The most famous name associated with this endeavour was that of the playwright Frank Wedekind, but the great success of the opening night was scored by the actress Marya Delvard, who is depicted in the poster as she appeared on that occasion, a tight black dress contrasting dramatically with her deathly pallor. Thomas Theodor Heine is best known for his illustrations for the provocative revue *Simplicissimus*. He has brought a blackly humorous touch to the familiar image of the femme fatale, which he has exaggerated to the point of travesty.

Pablo Picasso (1881-1973)

40 *Courtesan with a jewelled collar* 1901, oils.
This type of contemporary femme fatale appeared frequently in Picasso's work at the turn of the century. Sinister and melancholic women continue in his paintings until the advent of Cubism, which was a style inimical to literary subject matter. Like Klimt, Picasso uses the jewelled collar to create a disturbing impression of mutilation. Picasso also delights in the elaborate construction of fashionably piled-up hair and ostrich feathers.

Acknowledgements

I would like to acknowledge the help of Muriel Jeancard who traced many of the illustrations for this book in France, of Jo Foster who typed the manuscript and of the photographers Angelo Hornak and John Webb. I would also like to thank Dr Anita Brookner for her kind encouragement, Robert MacCarron for putting his library and his knowledge of Victorian literature at my disposal, Alison Burns for many useful suggestions and Jane Weinstock for her criticism of the text from a feminist standpoint. Most of all I would like to thank my editor, Susan Hyman, who was a stimulating working companion and offered me invaluable help at every stage of the book.

Picture credits

1, Private collection; 2, Collection Flamand Charbonnier (Photo: AGRACI) (SPADEM); 4, Private collection; 5, City of Manchester Art Galleries; 6 top, Victoria and Albert Museum, London (Photo: Angelo Hornak); 6 bottom, Staatliches Museum, Schwerin; 7 top, Musée des Beaux-Arts, Brest (Photo: R. Guillemot, Agence Top); 7 centre, Boymans-van Beuningen Museum, Rotterdam; 7 left, Private collection (Photo: Roger Viollet) (SPADEM); 8 top, National-Galerie, Berlin; 8 bottom, Private collection (Photo: Bulloz) (SPADEM); 8 right, National Gallery of Victoria, Melbourne; 9 top, Private collection (Photo: John Webb); 9 centre, Editions Graphiques Gallery, London; 9 bottom, Radio Times Hulton Picture Library; 10, Private collection, Milan; 11 top left, Musée Rodin, Paris (Photo: Bulloz) (SPADEM); 11 top right, Musée des Beaux-Arts, Dijon (Photo: André Berlin, Roger Viollet); 11 bottom left, Museum der bildenden Künste, Leipzig; 11 bottom right, Collection Manoukian, Paris (Photo: Galerie Tanagra, Paris); 12, Fogg Art Museum, Harvard University (Grenville L. Winthrop Bequest); 13 top, Faringdon Collection Trust, Buscot Park; 13 bottom, Tate Gallery, London; 15 left, Fogg Art Museum, Harvard University (Grenville L. Winthrop Bequest); 15 top right, Maas Gallery, London; 15 bottom right, By Permission of the British Library; 16 top, Fogg Art Museum, Harvard University (Scofield Thayer Loan); 16 bottom, By Permission of the British Library; 17, Bibliothèque littéraire Jacques Doucet, Paris (Photo: Bernard Jourdes, Paris); 18 top, Collection Flamand Charbonnier (Photo: AGRACI) (SPADEM); 18 bottom, Editions Graphiques Gallery, London; 19, Kunsthistorisches Museum, Vienna; 20 left, Bibliothèque Nationale, Paris; 20 right, Private collection; 21 top, Bibliothèque Nationale, Paris; 21 bottom, Bibliothèque Nationale, Paris (Photo: Snark) (ADAGP); 22, Louvre (Photo: Giraudon); 23, Bibliothèque Nationale, Paris (Photo: Giraudon); 24 top, Munch Museum, Oslo; 24 bottom, Munch Museum, Oslo; 25 top, Munch Museum, Oslo; 25 bottom left, Munch Museum, Oslo; 25 bottom right, Hamlyn Group Picture Library; 26, Galerie Paul Vallotton, Lausanne; 28 top, Historisches Museum der Stadt Wien; 28 bottom, Private collection (Photo: O. E. Nelson) (SPADEM); 29, Bibliothèque de l'Opéra, Paris (Photo: Bibliothèque Nationale) (SPADEM); 30, Stadtische Galerie in Lenbachhaus, Munich; 31 top, Private collection; 31 bottom left, Collection Michel Perinet (Photo: Snark); 31 bottom right, Calouste Gulbenkian Foundation, Lisbon; 32 left, Brooklyn Museum (Dick S. Ramsay Fund); 32 centre, Hamlyn Group Picture Library; 32 right, Museum of Fine Arts, Boston; 33 top left, Tate Gallery, London; 33 top right, Lords Gallery, London (SPADEM); 33 bottom left, Osterreichische Galerie, Vienna; 33 bottom right, The Kobal Collection Ltd.; 34, Victoria and Albert Museum, London, by permission of William Heinemann Ltd publishers (Photo: Angelo Hornak); 35 top, Hessiches Landesmuseum, Darmstadt; 35 centre, Collection Reutlinger (© F. Nugeron, Paris); 35 bottom, reproduced from *Leon Bakst* by Charles Spencer (Photo: Academy Editions, London); 36 top (Photo: Giraudon) (SPADEM); 36 bottom, Louvre (Photo: Roger Viollet); 37 top, The Bettmann Archive; 37 bottom, National Gallery of Fine Arts, Smithsonian Instutution (Gift of Romaine Brooks); 38 left, Stuart Liff Collection; 38 right, Novosti Press Agency, London; 39 top, Stuart Liff Collection; 39 bottom, Twentieth Century – Fox Film Company Ltd. (Photo: British Film Institute); Pl. 1, City of Manchester Art Galleries (Photo: Cooper Bridgeman Library); Pl. 2, Tate Gallery, London (Photo: Eileen Tweedie); Pl. 3, Laing Art Gallery, Newcastle, and Tyne and Wear County Council Museums Service; Pl. 4, Birmingham Art Gallery (Photo: Cooper Bridgeman Library); Pl. 5, The Art Gallery of South Australia, Adelaide; Pl. 6, Hessiches Landesmuseum, Darmstadt; Pl. 7, Palais de Tokyo, Paris (Photo: Musées Nationaux, Paris); Pl. 8, Alfred East Art Gallery, Kettering Borough Council (Photo: Terry Rice); Pl. 9, Musée Gustave Moreau, Paris (Photo: Giraudon); Pl. 10, Cabinet des dessins, Louvre (Photo: Musées Nationaux, Paris); Pl. 11, Cabinet des dessins, Louvre (Photo: Musées Nationaux, Paris); Pl. 12, Collection Robert Walker, Paris (Photo: Cooper Bridgeman Library); Pl. 13, Editions Graphiques Gallery, London (Photo: Picadilly Gallery, London); Pl. 14, Collection Michel Perinet, Paris (Photo: Bulloz); Pl. 15, Collection Michel Perinet, Paris, (Photo: Bulloz); Pl. 16, Musées Royaux des Beaux-Arts de Belgique (SPADEM); Pl. 17, Collection E. Jannss-Junior (Photo: P. Willi, Agence Top); Pl. 18, Musées Royaux des Beaux-Arts de Belgique (SPADEM); Pl. 19, Kröller-Müller Foundation, Otterlo, Netherlands; Pl. 20, Collection Abraham Somer, Los Angeles, California (Photo: Picadilly Gallery, London); Pl. 21, The Walker Art Gallery, Liverpool; Pl. 22, Cabinet des dessins, Louvre (Photo: P. Willi, Agence Top); Pl. 23, Novosti Press Agency, London; Pl. 24, Louvre (Photo: Giraudon); Pl. 25, Munch Museum, Oslo; Pl. 26, Rasmus Meyer Museum, Bergen; Pl. 27, Collection Stuart Pivar, New York; Pl. 28, Collection Barry Friedman Ltd., New York (Photo: Hammer Galleries, New York) (SPADEM); Pl. 29, The Walker Art Gallery, Liverpool; Pl. 30, Collection Jacques Bernard, Paris; Pl. 31, Private collection (SPADEM); Pl. 32, Collection Barry Friedman Ltd., New York; Pl. 33, Musée des Beaux-Arts Jules Chéret, Nice (SPADEM); Pl. 34, Osterreichische Galerie, Vienna; Pl. 35, Petit Palais, Paris (Photo: AGRACI) (SPADEM); Pl. 36, Tate Gallery, London (Photo: Eileen Tweedie); Pl. 37, Victoria and Albert Museum, London (Photo: Angelo Hornak); Pl. 38, By Permission of the British Library and Hodder & Stoughton Ltd.; Pl. 39, Theatre Museum, Munich; Pl. 40, Mr & Mrs George Gard De Sylva Collection, Los Angeles County Museum of Art (SPADEM); Quotations from J.-K. Huysmans, *Against Nature* translated by Robert Baldick reprinted by permission of Penguin Books Ltd.

Index